WORLD FILM LOCATIONS VIENNA

Edited by Robert Dassanowsky

First Published in the UK in 2012 by Intellect Books, The Mill, Parnall Road, Fishponds, Bristol, BS16 3JG, UK

First Published in the USA in 2012 by Intellect Books, The University of Chicago Press, 1427 E. 60th Street, Chicago, IL 60637, USA

Copyright ©2012 Intellect Ltd

Cover photo: *Before Sunrise*, 1995 (Castle Rock/Detour The Kobal Collection)

Copy Editor: Emma Rhys

A Catalogue record for this book is available from the British Library

World Film Locations Series
ISSN: 2045-9009
eISSN: 2045-9017

World Film Locations Vienna
ISBN: 978-1-84150-569-5
eISBN: 978-1-84150-736-1

Printed and bound by Bell & Bain Limited, Glasgow

WORLD
FILM
LOCATIONS
VIENNA

EDITOR
Robert Dassanowsky

SERIES EDITOR & DESIGN
Gabriel Solomons

CONTRIBUTORS
Thomas Ballhausen
Michael Burri
Robert Dassanowsky
Laura Detre
Todd Herzog
Susan Ingram
Dagmar C. G. Lorenz
Joesph W. Moser
Markus Reisenleitner
Arno Russegger
Nikhil Sathe
Heidi Schlipphacke
Oliver C. Speck
Justin Vicari
Mary Wauchope

LOCATION PHOTOGRAPHY
Severin Dostal
(unless otherwise credited)

LOCATION MAPS
Joel Keightley

PUBLISHED BY
Intellect
The Mill, Parnall Road,
Fishponds, Bristol, BS16 3JG, UK
T: +44 (0) 117 9589910
F: +44 (0) 117 9589911
E: *info@intellectbooks.com*

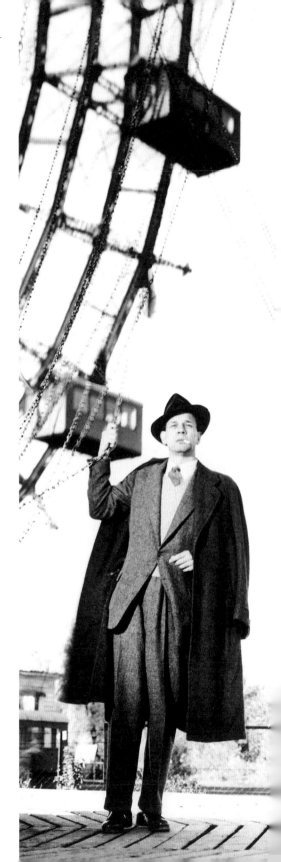

CONTENTS

Maps/Scenes

10 **Scenes 1-8**
1922 - 1936

30 **Scenes 9-16**
1936 - 1955

50 **Scenes 17-24**
1957 - 1976

70 **Scenes 25-32**
1976 - 1986

90 **Scenes 33-39**
1987 - 2001

108 **Scenes 40-46**
2001 - 2011

Essays

6 **Vienna:
City of the Imagination**
Michael Burri

8 **Vienna Imperial
at Home and Abroad:
The City as Film Myth
in the 1930s and 1940s**
Joseph W. Moser

28 **Vienna and the Films
of Louise Kolm-Veltée**
Robert Dassanowsky

48 **The Jewish Topography
of Filmic Vienna**
Dagmar C. G. Lorenz

68 **Vienna in Film 1945–55:
Building a Post-War Identity**
Mary Wauchope

88 **Wonder Wheel:
The Cinematic Prater**
Todd Herzog

106 **The Spaces of
The Other Vienna in
New Austrian Film**
Nikhil Sathe

Backpages
124 Resources
125 Contributors
128 Filmography

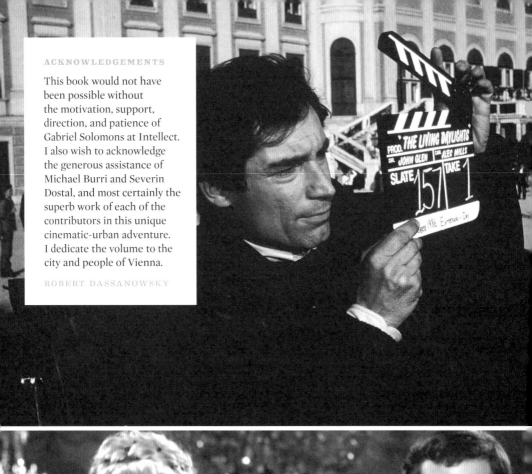

ACKNOWLEDGEMENTS

This book would not have been possible without the motivation, support, direction, and patience of Gabriel Solomons at Intellect. I also wish to acknowledge the generous assistance of Michael Burri and Severin Dostal, and most certainly the superb work of each of the contributors in this unique cinematic-urban adventure. I dedicate the volume to the city and people of Vienna.

ROBERT DASSANOWSKY

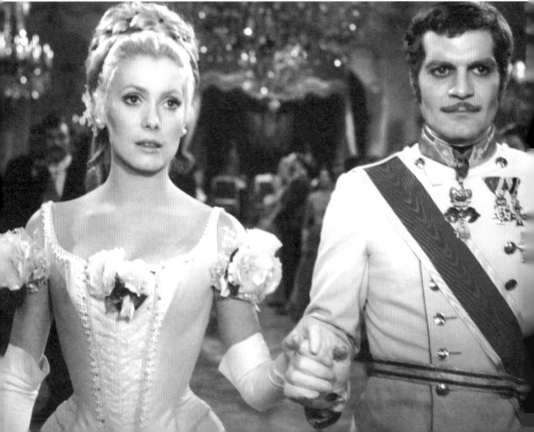

INTRODUCTION

World Film Locations *Vienna*

'THE VIENNA THAT NEVER WAS, is the greatest city in the world,' commented Orson Welles as he attempted to film an experimental spy spoof on its grand circular boulevard of palaces, government buildings, museums and parks, the Ringstrasse, in 1968. He had become familiar with the city at a time in which it was at its least traditionally cinematic, as his character Harry Lime darted in and out of the war-torn shadows of *The Third Man* (Carol Reed, 1949). Along with *The Sound of Music* (Robert Wise, 1965), which is set wholly in Salzburg and its environs (on location for the most part), and a few additional films, these cinematic memories represent Austria in much of the world's imagination.

Throughout western film history Vienna, its capital, has most often appeared as a fantasy based on the imperial city it was until 1918. Austrian film took the lead in the perpetuation of this lost world with the 'Viennese Film' of the 1930s and 1940s, a genre that was remade and imitated by Hollywood, often by its sizeable Austrian-Hungarian expatriate and exile population, which also contributed to the myth (e.g. Josef von Sternberg's *Dishonored* [1931], Henry Koster's *Spring Parade* [1940], Billy Wilder's *The Emperor Waltz* [1948], Michael Curtiz's *A Breath of Scandal* [1960], etc.). During the post-war Austrian film industry boom, Vienna was able to market itself on an international scale with historical backdrops for opulent Agfacolor melodramas, comedies, and operettas based on the myths of the Habsburg dynasty and the aristocratic-bourgeois world of the nineteenth and early twentieth century. The most indelible of these imperial epics is Ernst Marischka's *Sissi* series (1955–57) which made a world star of Romy Schneider and permanently romanticized the reputation of the penultimate Austrian Empress, Elisabeth or 'Sissi'.

Vienna, much like Paris, is a film city obsessed with love – from pre-*Blue Angel* Marlene Dietrich and Willi Forst in *Café Elektric/Cafe Electric* (Gustav Ucicky, 1924) to Omar Sharif and Catherine Deneuve in *Mayerling* (Terence Young, 1968) to Ethan Hawke and Julie Delpy in *Before Sunset* (Richard Linklater, 1994) – albeit this attitude presents a somewhat thornier prospect in the city of Freud, as the recent *A Dangerous Method* (David Cronenberg, 2011) aptly underscores. There have, of course, been other cinematic associations and Vienna has functioned as a stand-in for Budapest (*The Journey* [Anatole Litvak, 1959]), a Vienna-esque Sweden (*A Little Night Music* [Harold Prince, 1977]), Moscow (*Firefox* [Clint Eastwood, 1982]) and Paris (*The Three Musketeers* [Stephen Herek, 1993]), while 'Old Vienna' has ironically been shot in Prague (*Amadeus* [Milos Forman, 1984]; *The Illusionist* [Neil Burger, 2006]) and Paris (*Julia* [Fred Zinnemann, 1977]). New Austrian Film has introduced a grittier image of Vienna through the iconoclastic visions of its contemporary creators. But German film-maker Benjamin Heisenberg insists that Vienna remains 'a fantastic cinema city'. Beyond its iconic historical sites and new landscapes there are views that 'are not particularly beautiful and not touristic, but very exciting'. ✦

Robert Dassanowsky, Editor

VIENNA

City of the Imagination

Text by
MICHAEL
BURRI

A PRODIGIOUS IMAGE MACHINE, Vienna excels as a global brand. Far from the city's landmarks: St Stephen's Cathedral, the Schönbrunn Palace, and the Ringstrasse, a lightly stamped 'made in Vienna' is recognizable in character types and stories, sounds, settings and choreographies. Meanwhile, an aspirational Viennese lifestyle can be found in virtually any major North American or European city. A European cousin to Hollywood, Vienna is a soft power empire whose fictions and fantasies have colonized our imagination. This Vienna belongs to the world. But Vienna also belongs to film-makers who – whether they embrace or reject it – struggle with the extraordinary success of the global brand Vienna. Vienna films are always a tale of two cities. The first Vienna is a vast aggregation of artifacts, emotional associations, and histories – monarchy, Mozart, Freud, Blue Danube, two catastrophic world wars, and the rest. The second Vienna is the city that film directors adapt, redefine, and remake in the shadow of the first. Films set in Vienna thus unfold amid a surplus of images. The city does not have to introduce itself: we already know too much.

Ernst Lubitsch once quipped that he might prefer Paris, Paramount to Paris, France. Early big-budget films tended to present a studio Vienna reconstructed around visually dominant locations. In *Der junge Medarus/ The Young Medarus* (1923) the pre-Hollywood Michael Curtiz recreated Schönbrunn, St Charles Church, and St Stephen's as alternating backdrops. *The Wedding March* (1928), by Vienna-born Erich von Stroheim, actually did substitute Vienna, Paramount for Vienna, Austria. Like his *Merry-Go-Round* (1923), whose budget-busting rebuilding of Vienna in a southern California backlot cost him his director's job, *The Wedding March* mapped social hierarchies onto the urban space. The inner city marks the merging of religious and imperial tradition, high culture and the elite male, while the suburban periphery features popular entertainment, commerce, and the erotically-charged lower-class female.

Some early films did combine studio interiors with iconic city exteriors. Gustav Ucicky's *Café Elektric/Cafe Electric* (1927) casts St Stephen's as a distant crime scene backdrop, while Paul Fejös's *Sonnenstrahl/Ray of Sunshine* (1933) transfers its visual focus from the old urban landmarks to the monumental apartment buildings recently built in the outer districts by the municipal socialist government. More characteristic, however, was Lubitsch's *The Smiling Lieutenant* (1931), a remake of Ludwig Berger's *Ein Walzertraum/A Waltz Dream* (1925), filmed at Vienna, Paramount. Stock footage of the cathedral-spired and domed skyline, Hofburg Palace and the Graben establish location and then yield to a Vienna of opulent interiors, garden restaurants and romantic park benches.

Recognizable cityscapes and exterior locations, even when reconstructed, imply an engagement with politics and a willingness to acknowledge a socially precarious urban environment. But it was the relocation of

Opposite © 2001 Allegro Film / Above © 1927 Sascha-Film

characters, situations and urban topographies. To this synthesis belongs Vienna as a transitory space, a neutral frontier city, located between the 'free' West and the soviet East. Leopold Lindtberg's *Die Vier im Jeep/Four in a Jeep* (1951) and John Glen's *The Living Daylights* (1987), among other works, testify to Vienna as a locus classicus of the Cold War genre film. Of course, not every reworking in *The Third Man* enjoyed such an auspicious afterlife. Emil Reinert's *Abenteuer in Wien/Adventure in Vienna* (1952) remains one of the few attempts at a Viennese film-noir style. And one wonders whether Reed would claim Guido Zurli's *Lo Strangolatore di Vienna/The Mad Butcher* (1971), the story of a narcissistic and murderous profiteer who treats his victims as meat, among his cinematic progeny.

Recent generations of Austrian film-makers have increasingly argued that Viennese films too often say what has already been said, rather than how people actually live in Vienna. As a result, and in response to the widespread perception that the inner city has become an enclave of the rich and famous, New Wave Austrian film has tended to find its stories in the outer districts and social periphery. Ulrich Seidel's *Hundstage/Dog Days* (2001) and Götz Spielmann's *Antares* (2004) stand here for many. And yet, certain locations continue to catalyse certain kinds of action. The Prater marks the place of casual encounters and improbable twists of fate. Thus, Willy Schmidt-Gentner's *Prater* (1936), the story of an unlikely romance that begins there, speaks across decades to Wilhelm Pellert's sharply critical *Jesus von Ottakring/Jesus of Ottakring* (1976), in which a factory owner, randomly harassed by thugs at the Prater, subsequently hires those thugs to commit his crimes. And a rescue from drowning in *Sonnenstrahl/Ray of Sunshine* (1933) at the Danube River, a traditional site of danger and ruined lives, is echoed nearly half a century later in Peter Patzak's *Den Tüchtigen gehört die Welt/The Uppercrust* (1981), a dark tale of politics and crooked property deals along the river. Meanwhile, feature television films, like the irregular detective series *Trautmann* (2000–08), have invested less traditional public spaces such as the Second District's Karmeliter Markt with new imaginative energy. The global brand of Vienna is hardly at risk, but we can continue to count on new additions to that blessing and curse – its surplus of images. ✢

dramatic action to interior spaces that in the 1930s films of Willi Forst produced the most enduring and emulated cinematic articulation of Vienna. Indeed, his directorial debut, *Leise flehen meine Lieder/Gently My Songs Entreat* (1933) may be seen as an ironic farewell to the exterior location. Opening with a shot of St Stephens's, the camera pulls back. The image is revealed as a painting, freight on someone's back, on its way to a pawnshop to be sold. With *Maskerade/ Masquerade* (1934), Forst – whom a 1936 German film trade paper called the 'man who created a city' – most fully elaborated the formula of the 'Viennese Film'. Its visual centre is the ballroom, a location that masterfully fused core elements of the Viennese brand: high society, music, conviviality, romantic intrigue and perhaps, above all, the waltz – the last an element ideally suited to cinematic representation and proprietarily Viennese.

It should be impossible to open a film with the phrase, 'I never knew the old Vienna.' But Carol Reed's *The Third Man* (1949) did just that, and in retrospect, the post-war years offered a brief window in which such a helpless confession seemed sensible, even desirable. Reed's masterpiece shattered the consensus around the older 'Viennese Film', if such a consensus ever existed, and delivered a new synthesis of Viennese

…in response to the widespread perception that the inner city has become an enclave of the rich and famous. New Wave Austrian film has tended to find its stories in the outer districts and social periphery.

VIENNA IMPERIAL AT HOME AND ABROAD

Text by JOSEPH W. MOSER

The City as Film Myth in the 1930s and 1940s

FOLLOWING THE DEFEAT in World War I, Vienna struggled with its new identity after 1918 as the capital of the small First Republic of Austria. As the economic and political crisis of the 1920s and 1930s were taking its toll on this city, film-makers discovered that a 'grand' Vienna was a successful film subject. Much of this image of the city, however, was created in Vienna studios rather than 'on location'. The fantasy imperial image of the city had begun with operetta themes in silent film which were popular in export. At home, social-critical urban melodramas that dispelled such imagery were in fact more popular. The mythic Vienna in Austrian cinema is located in films sometime between the Vienna Congress of 1815 and the outbreak of World War I in 1914, during a century of peace under the rule of the Habsburg monarchs. Vienna is never depicted as the capital of a fierce empire, but rather as an elegant and jovial city, thus quite a contrast to filmic imagery of Berlin. The myth, however, ignores the fact that Vienna was de facto the capital of central Europe attracting a tremendous amount of immigration from across the continent, including a Jewish minority that accounted for a tenth of the city's population. The films also do not explore the stark economic differences between the ruling classes and the vast majority of poor working-class Viennese, many of whom had immigrant backgrounds.

Hollywood studios also underscored and exported a romanticized imperial and post-World War I period Vienna in such films as *The Wedding March* (1928) by Austrian-expatriate Erich von Stroheim, *Viennese Nights* (1930) by Allan Crosland and Oscar Hammerstein II, *Dishonored* (1931) by Viennese-Hollywood director Josef von Sternberg, *Daybreak* (1931) based on Arthur Schnitzler's *Traumnovelle* (*Dream Story*, also used by Kubrick for *Eyes Wide Shut* [1999]) by Jacques Feyder, *Reunion in Vienna* (1933) by Sidney Franklin, and *The Night is Young* (1935) by Dudley Murphy and Vienna-born Hollywood writer Vicki Baum.

With the onset of sound production in Vienna, actor-director Willi Forst and writer Walter Reisch contributed greatly to this mythic image of Vienna through their Viennese Film genre. This concept has often been generalized to include any film that offers a sentimentalized image of Vienna with a narrative in or suggesting Viennese dialect. But in its strictest original definition, it was

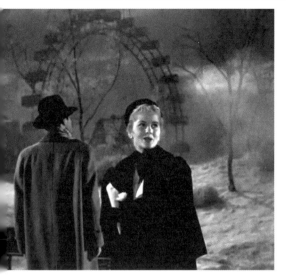

an elegantly stylized orchestration of period romantic melodrama, music, Viennese locales and stereotypes, and most often a variation on the theme of the artist sacrificing love for art. The classic early films include *Leise flehen meine Lieder/Gently My Songs Entreat* (Willi Forst, 1933; remade as *Unfinished Symphony* by Anthony Asquith in London in 1934), *Maskerade/Masquerade* (Willi Forst, 1934; which made a star of actress of Paula Wessely and was remade as *Escapade* by Robert Z. Leonard at MGM the same year with Reisch contributing a revision of his original screenplay), and *Episode* (Walter Reisch, 1935). Reisch also scripted *The Great Waltz* (Julien Duvivier, 1938), MGM's Johann Strauss epic which launched his important career in Hollywood (*Ninotchka* [1939], *Gaslight* [1944], *Niagara* [1953], *Titanic* [1953]). The Viennese Film and variants proved to be popular for other Austrian directors with mixed studio and on-location productions: *Frühjahrsparade/Spring Parade* (Geza von Bolvary, 1934), *Hoheit tanzt Walzer/Eternal Waltz* (Max Neufeld, 1935); as did its more

Continuation of Vienna's production of Viennese Film after Austria's annexation to Nazi Germany in 1938 was a market-driven strategy as well as the regime's co-opting of Austrian cultural history as propaganda for a 'Greater Germany'.

contemporary variants: the class-conflict Lehár operetta, *Eva* (Johannes Reimann, 1935), *Sylvia und ihr Chauffeur/Waltz around the Stephenstower* (J. A. Hübler-Kahla, 1935) and *Rendezvous in Vienna* (Victor Jansen, 1936). The Habsburg romance and the Viennese Film/Musical was also produced in Germany: *Liebelei/Flirtation* (Max Ophüls, 1933), *Endstation/Last Stop* (E. W. Emo, 1935), *Romanze/Romance* (Herbert Selpin, 1936), in France *Mayerling* (Anatole Litvak, 1936), *De Mayerling à Sarajevo/From Mayerling to Sarajevo* (Max Ophüls, 1940), and Britain *Good Night, Vienna* (Herbert Wilcox, 1932), *Bitter Sweet* (Herbert Wilcox/Noel Coward 1933), *Waltzes from Vienna* (Alfred Hitchcock, 1934).

Continuation of Vienna's production of Viennese Film after Austria's annexation to Nazi Germany in 1938 was a market-driven strategy as well as the regime's co-opting of Austrian cultural history as propaganda for a 'Greater Germany'. Willi Forst created his most impressive film work in a musical trilogy on Old Vienna (partially shot on location) during the Nazi regime with *Operette/Operetta* (1940), *Wiener Blut/Viennese Blood* (1942) and *Wiener Mädeln/Young Girls of Vienna* (1945/49). Viennese comedic actors Hans Moser and Paul Hörbiger were among the highest paid actors during the Nazi era, and starred in several comedies set in Vienna that were extremely popular with audiences across occupied Europe. They established Vienna and the cinematic Viennese way of life as the most charming of all German-speaking cities. But this enforced rather than negated the memory of the forbidden independent Austria at home.

Although Carol Reed's *The Third Man* (1949) offered on-location war-torn realism, Hollywood continued to market back-lot imperial Habsburg-era Vienna throughout and following the war with *Juarez* (William Dieterle, 1939; based in-part on exiled Austrian author Franz Werfel's play on the doomed Habsburg Emperor Maximilian of Mexico), *Spring Parade* (Henry Koster, 1940; a remake of the 1934 *Frühlingsparade*), *They Dare Not Love* (James Whale/Victor Fleming, 1941), *Letter from an Unknown Woman* (Max Ophüls, 1948) and *The Emperor Waltz* (Billy Wilder, 1948). Austrian film picked up the city's mythic-romantic image once more in its opulent imperial epics of the 1950s and was able to use actual historical sites. ✛

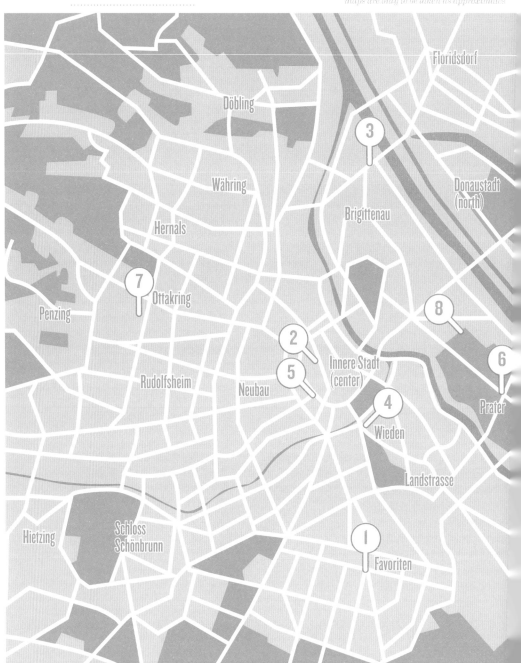

Floridsdorf

Döbling

3

Währing

Donaustadt (north)

Brigittenau

Hernals

7 Ottakring

8

Penzing

2

5

Innere Stadt (center)

6

Rudolfsheim

Neubau

4

Prater

Wieden

Landstrasse

Hietzing

Schloss Schönbrunn

1 Favoriten

VIENNA LOCATIONS
SCENES 1-8

Donaustadt (south)

immering

1.
THE QUEEN OF SIN AND THE SPECTACLE
OF SODOM AND GOMORRAH/
SODOM UND GOMORRHA (1922)
Laaer Berg, Filmteichstrasse, 10th District
page 12

2.
THE CITY WITHOUT JEWS/
DIE STADT OHNE JUDEN (1924)
Behind the Burgtheater (Court Theater)
on the Ringstrasse, 1st District
page 14

3.
RAY OF SUNSHINE/
SONNENSTRAHL (1933)
Wohnanlage am Friedrich Engels-Platz, 1-10
(Housing Complex on the Friedrich Engels
Square), 20th District
page 16

4.
VOICES OF SPRING/
FRÜHLINGSSTIMMEN (1933)
Vienna Academy (now University) of Music,
Lothringerstrasse 18, 3rd District
page 18

5.
LAST STOP/ENDSTATION (1935)
Street car 59 from Opera House to the
Naschmarkt in the 6th District
page 20

6.
THE BEST DAY OF MY LIFE/HEUT' IST DER
SCHÖNSTE TAG IN MEINEM LEBEN (1936)
The Prater Hauptallee (Prater Central
Boulevard), 2nd District
page 22

7.
AN ORPHAN BOY OF VIENNA/
SINGENDE JUGEND (1936)
Schloss Wilhelminenberg, Savoyenstrasse 2,
16th District
page 24

8.
PRATER (1936)
Prater Amusement Park, 2nd District
page 26

THE QUEEN OF SIN AND THE SPECTACLE OF SODOM AND GOMORRAH/SODOM UND GOMORRHA (1922)

LOCATION *Laaer Berg, Filmteichstrasse, 10th District*

IN THE MIDST OF an economic crisis that resulted in hyperinflation, mass unemployment and political radicalization, the Austrian film industry produced silent film epics of monumental scale on themes taken from the Old Testament and classical antiquity to rival Hollywood. The largest and most monumental of these films and perhaps the most expensive film ever produced in Austria, was *Sodom und Gomorrha*. The film juxtaposes a contemporary story of seduction, sin and redemption set in Vienna with a biblical tale that could be mobilized for designing, constructing and spectacularly destroying lavish, art deco-inspired sets of gigantic proportion. An appropriate setting was found on the Laaer Berg grounds, an abandoned site of clay pits and hilly grasslands at the southern edge of Vienna, which was landscaped to accommodate not only the historical sets (including a Babylonian temple and city gates) but also artificial roadways, a man-made lake, newly planted reeds and palm trees. Like the eponymous cities of the biblical story, these structures disappeared in an engineered Armageddon with the film's final take on 14 June 1922. For more than half a century, the site reverted to a little-used field overgrown with weeds, with only a plaque hinting at its former cinematic glory. However, on the occasion of the 1974 International Horticultural Show, then the largest show of its kind, another monumental endeavour began: the transformation of abandoned hills and clay pits into residential areas and a utilization of the location's thermal spring. Today only the name and manicured quality of the Kurpark (spa park) Oberlaa recalls its earlier incarnation of imagineered nature.
⇢ Susan Ingram and Markus Reisenleitner

Directed by Michael Curtiz (as Mihály Kertész)
Scene description: The Engagement Celebration
Timecode for scene: 0:10:22 – 0:21:09

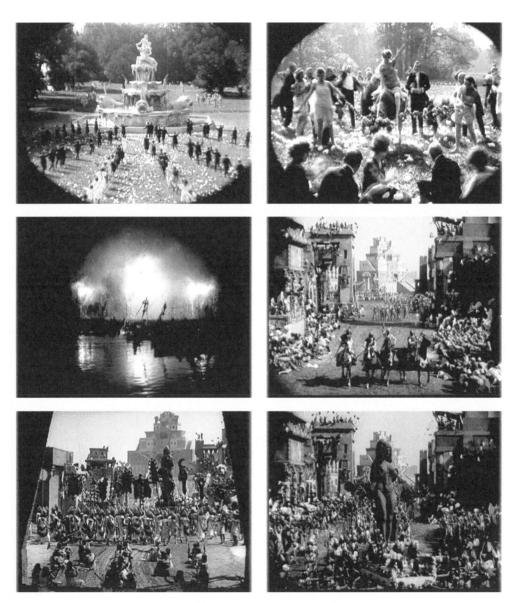

THE CITY WITHOUT JEWS/
DIE STADT OHNE JUDEN (1924)

LOCATION *Behind the Burgtheater (Court Theater) on the Ringstrasse, 1st District*

LONG BELIEVED LOST, a print of this rare example of Austrian cinematic expressionism was discovered and restored by the Film Archive Austria (FAA) in 1991. Its fantasy captures the social seismograph of inter-war central Europe and manages to articulate an anti-Semitism that was never presented in any documentary from the era. Based on the 1922 satiric novel by Hugo Bettauer (subtitled *A Novel of Tomorrow*), an anti-Semitic government in Vienna orders all Jews expelled, but this eventually results in cultural and economic disaster. Without the Jews to blame, the anti-Semitic party collapses and the people ultimately demand the return of the Jews. Known for his journalism, which often provoked right-wing forces in Austria, Bettauer was murdered by an Austrian Nazi eight months after the premiere of the film. Breslauer co-scripted the cinematic treatment of the novel with one of the very few German-language female film writers of the time, Ida Jenbach. It sets the action in the fictional city of Utopia, which is nevertheless clearly recognizable as the Austrian capital. The script also negates some of Bettauer's vitriol with a revised ending which reveals that the narrative has actually been the fevered dream of a now repentant politician (Hans Moser). A key scene of the film is the mob protest against the growing economic crisis, which according to the novel, takes place in front of Vienna's iconic Parliament building. Breslauer instead relocates it to the urban spaces *behind* the Burgtheater. Despite the blunting of the novel's ultimate statement, the director's skillful cinematic indications of the facade-like theatricality of politics and the underside of things makes this one of the most important and thought-provoking silent films in Austrian cinema history. ↪ ***Thomas Ballhausen***

Directed by Hans Karl Breslauer

Scene description: *Suffering a vast economic crisis, the outraged inhabitants of the city of Utopia stage a mass demonstration and demand political solutions*

Timecode for scene: *0:14:53 – 0:15:20*

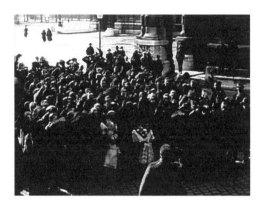 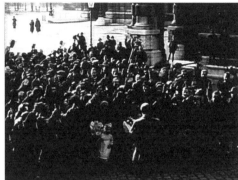

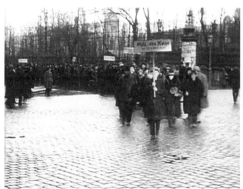 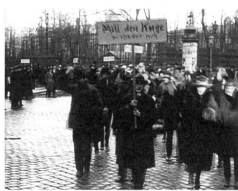

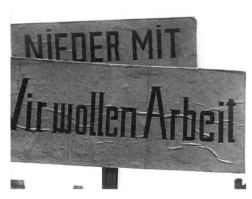 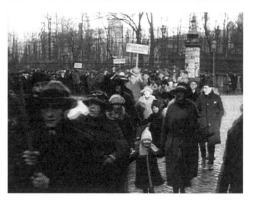

RAY OF SUNSHINE/
SONNENSTRAHL (1933)

LOCATION

Wohnanlage am Friedrich Engels-Platz, 1-10
(Housing Complex on the Friedrich Engels Square), 20th District

THE DEJECTED EVERYMAN Hans (Gustav Fröhlich) makes his way to the Danube Canal intending to end his life. He is interrupted by another figure with similar plans. A young woman Anna (Anabella) jumps into the canal and Hans follows her to save her from drowning in the dark waters. Rescued, he wraps himself around her freezing body in what is lit to suggest that this *ought* to be a romantic moment. But this narrative is propelled by its honest moments of humanity. What follows is the attempt of both characters to find work and a life together in a crushing financial crisis. Often compared to Capra, Fejös begins with the disaster that other social realist films might end with. The inversion makes fantasy impossible but allows for a story of hope and perhaps even a reasonable dream to be fulfilled. Failed opportunities, misadventures, and touching song interludes that mock the musical genre's bombast follow. The film concludes with what critic Fritz Rosenfeld at the time called 'An apotheosis of proletarian solidarity in Red Vienna'. The couple has managed to secure an apartment in the gleaming new public housing complex on the Friedrich Engels-Platz (erected 1930–33). Hospitalized, Hans cannot work and Anna alone cannot meet the payments for the taxi they have acquired. At the height of her desperation, with the unyielding collector attempting to repossess the taxi, the neighbours show that community is an extended family. From the balconies of the complex coins rain down on Anna so that she can manage the payment.
◆ Robert Dassanowsky

Directed by Paul Fejös
**Scene description: A man and woman losing hope find
their modest dream rescued by the working class**
Timecode for scene: 1:22:14 – 1:24:58

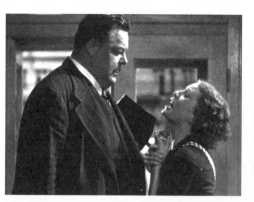 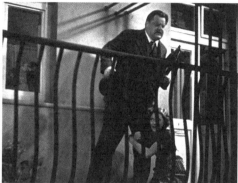

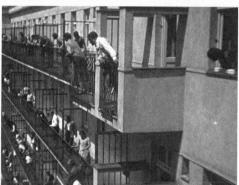 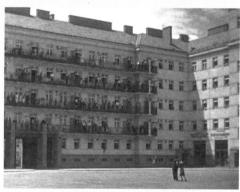

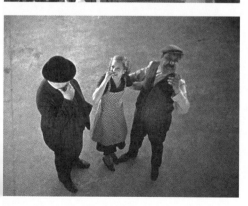 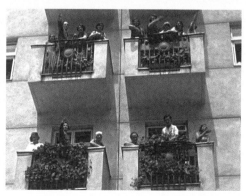

VOICES OF SPRING/
FRÜHLINGSSTIMMEN (1933)

LOCATION *Vienna Academy (now University) of Music, Lothringerstrasse 18, 3rd District*

AN IMPROMPTU AND HILARIOUS operatic 'jam' about sausages in the Academy's cafe underscores the gender role conflicts and artistic temperaments of the very modern characters in this romantic musical comedy that utilizes the melodies of Johann Strauss. The thin plot involving the two daughters of the Academy's overworked and befuddled porter (a pre-Hollywood S. Z. Sakall stealing the film) training for careers on the stage and an operetta-parody confusion regarding their fiancés, provides an entertaining structure by with the director presents the mores and tribulations of the 'new woman' who is self-determined, careerist, and frank about desire. One daughter, played by opera singer Adele Kern, gives the required high art performance; the other provides the screwball comedy angle. But despite its progressive frame and truly funny sight gags, the film never forgets that First Republic Vienna is in the midst of a major economic depression and political instability, and Kern's attempt to bolt her education for a premature career results in a poignant sequence in which she is faced with impoverished performers; one of them an elderly woman who informs her of the abuse that awaits (and not just her voice) from unscrupulous talent agents. The film's attempt to create continuity for Vienna's music culture identity and to stress the importance of education, particularly for young urban women in the age of radio, jazz, and men who openly reject their father's profession remains surprisingly fresh. **→Robert Dassanowsky**

Directed by Paul Fejös

Scene description: *An improvised opera between music students suggests the continuing war between the sexes*

Timecode for scene: *0:13:32 – 0:16:04*

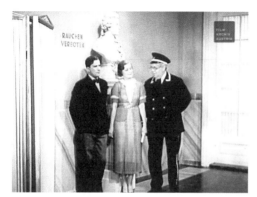
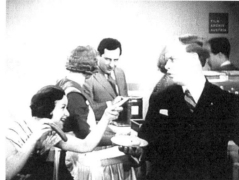
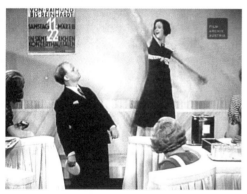
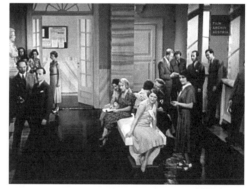

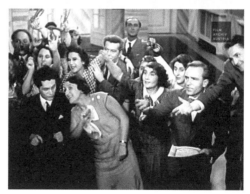

Images © 1933 Serge Otzoup-Filmproduktion/Tobis-Sascha

LAST STOP/ENDSTATION (1935)

Street car 59 from Opera House to the Naschmarkt in the 6th District

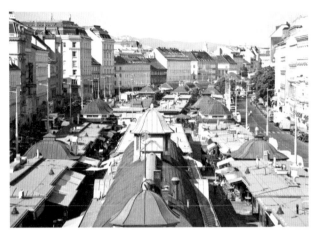

IN ENDSTATION, an attempt to create a variant on the popular Viennese Film in Berlin studios, we see extensive exterior shots made on location in Vienna along the Number 59 streetcar line, which at the time was among the longest in Vienna. It travelled from the outlaying suburb of Lainz past the famous landmark of the Naschmarkt, Vienna's largest and oldest open air marketplace (established around 1780) on the banks or 'Wienzeile' of the Vienna River canal, to the Opera House on the Ringstrasse and ending at the Neue Markt (New Market) in the centre of Vienna's First District. The streetcar no longer travels this route but in 1935, Anna (Maria Andergast), a seamstress employed in a posh millinery shop in the inner city, rides the line to deliver a large hat box to an important client in Lainz. The trolley conductor Karl (Paul Hörbiger) advises Anna that she cannot bring such a sizeable box on board and hangs it off the back of the car. Anna concernedly keeps an eye on the valuable package as the trolley makes its way past the Naschmarkt, where the box falls off the car and is run over by another trolley. The gallant Karl bails out the terrified Anna by replacing the hat which, of course, leads to more romantic comedy. Made three years before Austria's annexation to Nazi Germany, this film was a German-Austrian co-production made to racist specifications which excluded Jewish actors and film artists. The Naschmarkt has survived many attempts at relocation, modernization and even eradication. Now revitalized and under historical preservation, it continues its role as an international food market venue and also as an expanded area of new and varied ethnic restaurants and cafes. **•◦ Joseph W. Moser**

Directed by E. W. Emo
Scene description: Vienna's Streetcar Named Desire:
a woman, a trolley conductor and a hatbox
Timecode for scene: 0:06:30 – 0:08:45

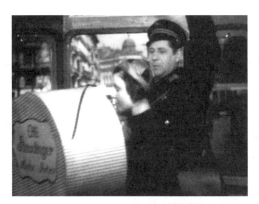 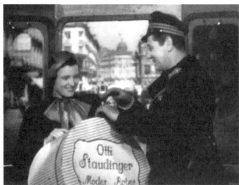

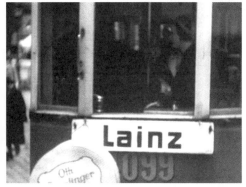 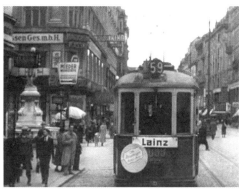

 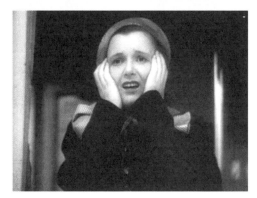

THE BEST DAY OF MY LIFE/
HEUT' IST DER SCHÖNSTE TAG IN MEINEM LEBEN (1936)

LOCATION *The Prater Hauptallee (Prater Central Boulevard), 2nd District*

THIS FILM HAS TWO STARS – the tenor Joseph Schmidt and the romantic outskirts of Vienna's Prater, which is the setting for the movie's most famous scene. In this act we see Schmidt as Tonio, a successful tenor recently returned to his hometown from a successful tour reconnecting with his Uncle Paul. They ride together in an elegant Viennese *Fiaker* (horse drawn carriage) down the idyllic Prater Hauptallee (Main Boulevard). This romantic road, densely lined with chestnut trees, is intended to suggest pleasure and relaxation to viewers. Both Schmidt and Otto Wallburg, who portrays Paul, play their roles with obvious delight. What followed the creation of this scene was however anything but peaceful for those involved. Director Richard Oswald and actor Felix Bressart, who played the character of Uncle Max, were forced by the rise of Nazism to flee to the United States and found work in Hollywood. Joseph Schmidt and Otto Wallburg were not so fortunate. Schmidt remained in Austria until just before the annexation to Germany in 1938 and then escaped to the Netherlands, southern France and finally Switzerland, where he was detained as an illegal immigrant of Jewish origin. Schmidt died in an internment camp near Gyrenbad, Switzerland in 1942. Wallburg also remained in Europe and fled to Amsterdam where he worked with the well-known German actor and director Kurt Gerron. Both men would eventually be sent to the Theresienstadt 'paradise camp' and ultimately to the gas chambers at Auschwitz. **↝Laura Detre**

Directed by Richard Oswald
Scene description: The reunion of a famous singer
and his uncle in idyllic, verdant Vienna
Timecode for scene: 1:03:11 – 1:07:45

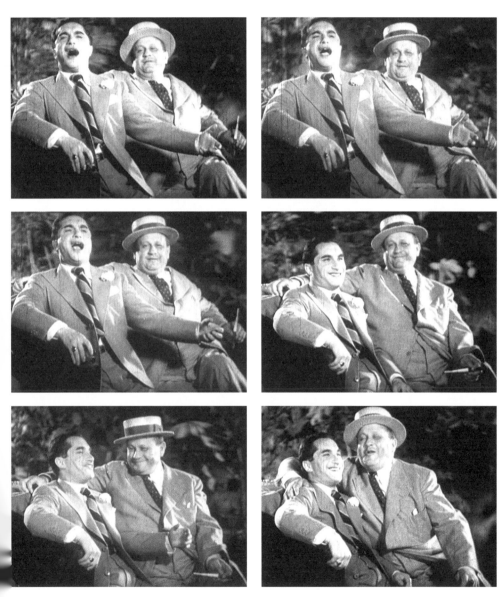

AN ORPHAN BOY OF VIENNA/ SINGENDE JUGEND (1936)

LOCATION *Schloss Wilhelminenberg, Savoyenstrasse 2, 16th District*

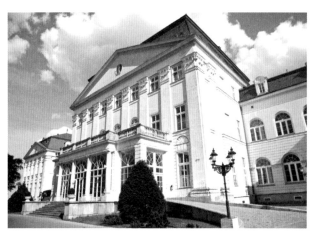

SCENES OF POVERTY AND ABUSE that is the life of the orphan boy Toni (Martin Lojda) opens the most famous of the few overtly Catholic-themed films produced during the clerico-authoritarian Austrian state (1933–38).The shelter he finds with a street musician (Hans Olden), a victim of unemployment but also a man of principles who becomes Toni's adopted father figure relates the economic hardships of the country, but also strong messages of cultural identity. Toni's significant vocal talents bring him to the Vienna Boys Choir where Sister Maria (Julia Janssen) becomes his mother figure and he learns the importance of duty, trust and faith. The film shifts location to the Tyrol to promote the regime's new highway connecting Vienna with the Alps, to allow for musical concerts, and provide for emotive melodrama. The film was something like the *Sound of Music* of its time – immensely popular throughout Europe and England (banned in Nazi Germany) and winning a best foreign film award from Czechoslovakia. An early scene in which the sailor-uniformed choir boys parade and sing operetta in the gardens of the Choir's home at the Wilhelminenberg Palace to the encouragement of their 'leader' Sister Maria, intentionally mocks the style and content of Hitler Youth films produced in Germany. The palace has come to represent the changes in Austria during the century: from a Habsburg residence to a World War I military hospital, veteran's centre, orphanage and finally the Choir Boys home, it was soon returned to military hospital service. Following the war, the city donated it to the care of concentration camp victims. It then once more became an orphanage and a special education facility, and now ranks as a popular hotel and conference site. **↦Robert Dassanowsky**

Directed by Max Neufeld

*Scene description: Sister Maria encourages a different
kind of regimentation among the boys in her charge*
Timecode for scene: 0:03:09 – 0:06:27

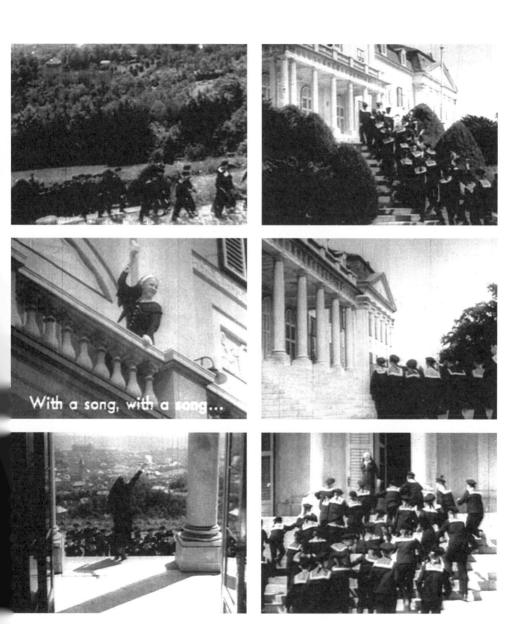

PRATER (1936)

Prater Amusement Park, 2nd District

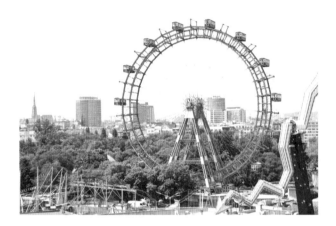

IS THERE A PLACE IN VIENNA more connected with cinema than the Prater? Already before film, it offered pre-cinematic visual experiences. The first booths to show films in 1896 helped stake the park's claim as Vienna's birthplace of the cinema theatre. It has remained a place for the projection of dreams and desires. The 1936 film *Prater* is the story of two young friends, Fred (Carl Esmond) and Nicki (Hans Olden), and the charming Tini (Magda Schneider). Both men show interest in the young woman, whom they have met in the Prater, but Fred is clearly infatuated. A montage sequence on the iconic Prater Geisterbahn (ghost train) ride signals their budding romance. But such lighthearted bliss is, of course, temporary. The easygoing Nicki makes a living as a popular singer, but the over-serious Fred is a frustrated painter unable to act as a salesman for his own works. The naive Tini secretly approaches Baron Castelli (Fred Hennings) to help sell Fred's paintings. A scoundrel, he invites her to the Prater, where he pours spiked champagne and attempts to seduce her in a private salon. Tini manages to escape, but Fred now rejects her because he has seen her in the Baron's car. Desperate, Tini runs to the raging Danube and jumps in. Anything is possible at the Prater. It is a place where the restrictions of everyday life are suspended, but in the face of this perpetual state of unreality, the *Prater* tells us, you need to keep your cool. Tini survives, and Fred has a change of heart. Still, it is the easygoing singer Nicki who delivers melodic wisdom: 'Always keep a sense of humor. At life's worst moments, smile a bit.' ➥ *Michael Burri*

Directed by Willy Schmidt-Gentner
Scene description: Fred and Tini's trip on a Prater ride
signals the start of romance – and near tragedy
Timecode for scene: 0:11:20 – 0:12:25

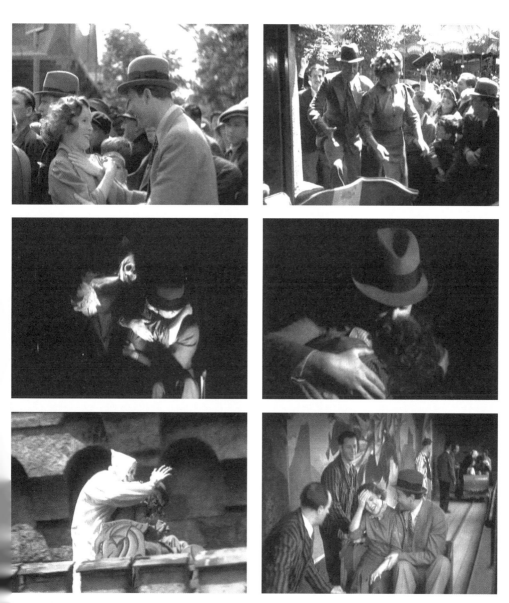

VIENNA AND THE FILMS OF LOUISE KOLM-VELTÉE

Text by
ROBERT
DASSANOWSKY

WHILE FRANCE'S ALICE GUY (1876–1968) has had her pioneering role as the earliest feature filmmaker often qualified by her gender as the 'first female film director', the prolific studio founder, writer, director and producer Louise Veltée (or Louise Kolm aka Louise Fleck) was, until very recently, missing from cinema scholarship. In 1896, Louise's father, Louis Veltée, began showing films in his wax museum on the First District's fashionable Kohlmarkt street near the imperial Hofburg palace, and swiftly became known as the father of the Austrian movie theatre. Louise (or Luise), worked as a cashier at her father's business and learned about the nascent art from one of its very first public practitioners. While Count Alexander von Kolowrat-Krakowsky (known as Sascha Kolowrat, 1896–1927) has traditionally been labelled the father of the Austrian film industry, the first

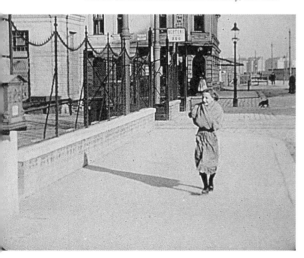

to actually produce feature films were Louise Veltée (1873–1950), her husband, Anton Kolm (1865–1922) and their cameraman Jakob Julius Fleck (1881–1953). Erotic films were re-discovered in the late 1990s which appear to predate the trio's productions, but it was the Kolm–Fleck efforts, beginning in 1906, that mark the beginning of an actual Vienna-based film industry in the Austro-Hungarian Empire.

In January 1910, the first true Austrian film production company was formed by Louise and Anton Kolm with Jakob Fleck in a spacious and prominent building at Währingerstrasse (9th District). Although the French had long held the rights to film at the imperial court, Kolm–Fleck managed to secure the privilege of filming Emperor Franz Joseph during his visit to a Vienna flying field, and thus secured their placement as Austria–Hungary's pre-eminent film company. Their production of *Der Müller und sein Kind/The Miller and his Child* (1910), the earliest existing Austrian feature film, was the first to establish the concept of a prop company. Two films soon displayed a more sophisticated style of film writing, acting and music composition: *Das goldene Wiener Herz/The Golden Viennese Heart* (1911) and *Die Glückspuppe/The Doll of Happiness* (1911) which was written and directed by Louise Kolm along with her team with whom she always shared credit: Anton Kolm and Jakob Fleck. She insured that pre-production of the crime drama *Der Unbekannte/The Unknown Man* (1912), for which she was credited as sole director, built anticipation in a manner that has since become a convention of international film-making.

Most of the films during this prolific phase of the Kolm–Fleck partnership were socially

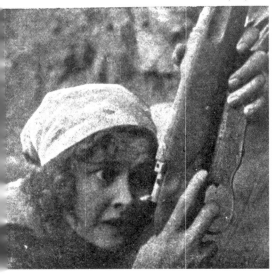

Opposite © 1911 Erste österreichische Kinofilms-industrie
Above © 1915 Erste österreichische Kinofilms-industrie

from famed Viennese cultural critic Karl Kraus (1874–1936), who detested the use of film (particularly the manipulated war reportage by Kolowrat) for the sake of propaganda and as a form of 'emotional war' on the audiences. Kraus's 1919 play *Die letzten Tage der Menschheit* (*The Final Days of Mankind*), gives a cynical portrayal of the influence of motion pictures. After the concerted effort by film-makers to bring literature into the cinema, cinema had now finally become part of literature.

Not all production was dedicated to war propaganda. The Kolm–Fleck team filmed Austrian folk-dramatist Ferdinand Raimund's magical tale, *Der Verschwender/The Spendthrift* in 1917, and used it to build up the career of its actress Liane Haid (1895–2000), the first true Austrian film star. She followed this with Louise and Anton Kolm's *Eva, die Sünde/Eva, The Sin* (1920), in which she portrays a femme fatale who attempts to seduce a monk – an early indication of Louise Kolm's continuing desire to break traditional gender norms in her films. Although these films were considered large-scale costume dramas for the time, every attempt was made to reduce costs while giving impressive production values. The gothic 'sets' of *Der König amusiert sich/Rigoletto* (1918) based on the Victor Hugo novel for example, were not constructed in a studio but were actual examples of neo-Gothic architecture found in Vienna, such as the famed Rathaus (City Hall) on the Ringstrasse (Rathausplatz, 1st District).

With the collapse of the Empire and the birth of the Austrian Republic, Kolm-Fleck countered Vienna's Kolowrat studio with a new facility constructed in the Rosenhügel section of Vienna (Speisingerstrasse 121-127, 23rd District). Following Anton Kolm's death in 1922, Louise Kolm and Jakob Fleck relocated to Berlin, where they married and Louise would continue to write and co-direct, now with her second husband, into the 1930s. The studio they had founded was expanded and for a time became the most modern and technically advanced film production facility in Europe under different company names (including Tobis-Sascha and Wien-Film). It has survived all other major studios in Vienna and is today utilized as a state-of-the-art television and film production facility known as Filmstadt Wien (Film City Vienna) or simply as the Rosenhügel Studio. ✤

critical melodramas, such as *Das Proletarierherz/The Heart of the Proletarian* (1913). An attempt at melding documentary, operetta and feature film on a subject which has become one of the more popular 'Viennese' themes in international film history, *Johann Strauss an der schönen blauen Donau/Johann Strauss on the Beautiful Blue Danube* in 1913, was a misfire despite its lavish conception and its premiere which coincided with the unveiling of the Johann Strauss Memorial in Vienna's Stadtpark or City Park (Parkring, 1st District).

Kolm's company was also significant in bringing the Great War into the cinemas. These films melded heroic notions with sentimental drama and rousing melody or song. *Der Traum eines österreichischen Reservisten/The Dream of an Austrian Reserve Officer* (1915) was based on the tone-poem by Carl Michael Ziehrer. Louise Kolm and Jakob Fleck also co-wrote and directed *Mit Herz und Hand fürs Vaterland/With Heart and Hand for the Fatherland* (1915) with songs by Vienna's beloved operetta composer, Franz Lehár. Although timely, the genre did not escape disapproval

In January 1910, the first true Austrian film production company was formed by Louise and Anton Kolm with Jakob Fleck in a spacious and prominent building at Währingerstrasse (9th District).

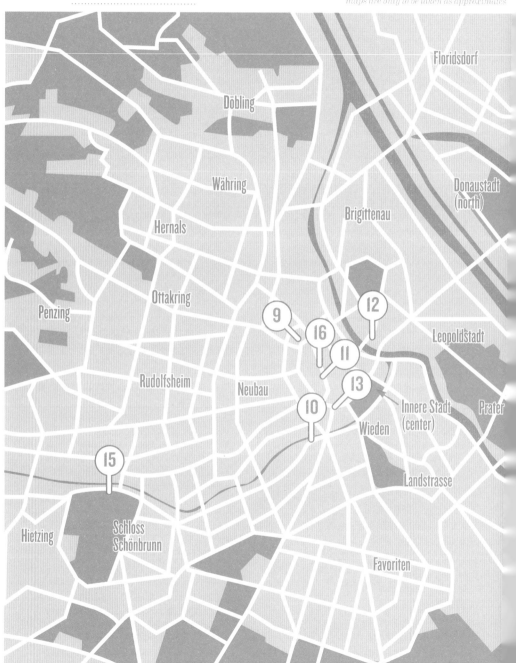

Floridsdorf

Döbling

Währing

Brigittenau

Donaustadt (north)

Hernals

Ottakring

Penzing

9

16

12

Leopoldstadt

11

Rudolfsheim

Neubau

13

10

Innere Stadt (center)

Prater

Wieden

15

Landstrasse

Hietzing

Schloss Schönbrunn

Favoriten

VIENNA LOCATIONS
SCENES 9-16

9.
COURT THEATER AKA BURG THEATER/
BURGTHEATER (1936)
Burgtheater, Universitätsring 2 (as of 2012;
formerly Dr Karl-Lueger-Ring), 1st District
page 32

10.
OPERETTA/OPERETTE (1940)
Theater an der Wien interiors,
Linke Wienzeile 6, 6th District
page 34

11.
THE THIRD MAN (1949)
Josefsplatz, 1st District
page 36

12.
THE RED DANUBE (1949)
Aspang Train Station, 3rd District
page 38

13.
FOUR IN A JEEP/DIE VIER IM JEEP (1951)
Neue Burg (New Castle wing), Hofburg
Palace and Ringstrasse, 1st District
page 40

14.
ADVENTURE IN VIENNA/
ABENTEUER IN WIEN (1952)
Vienna International Airport, in Schwechat,
south-east of Vienna
page 42

15.
APRIL 1, 2000/1. APRIL 2000 (1952)
Schönbrunn Palace Park, 13th District
page 44

16.
SISSI (1955)
St Michael's Cathedral, Michaelerplatz
(Michael's Square), 1st District
page 46

COURT THEATER AKA BURG THEATER/ BURGTHEATER (1936)

LOCATION

*Burgtheater, Universitätsring 2
(as of 2012; formerly Dr Karl-Lueger-Ring), 1st District*

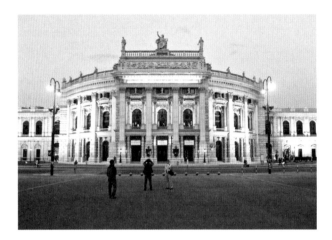

WITH THIS FILM two entertainment institutions of the inter-war years are melded – the reputation of the Austria's national theatre as the German – language stage, and the auteurial film-making of Willi Forst, creator of the Viennese Film genre (along with screenwriter Walter Reisch) which gave Austria its cinematic identity in the 1930s and was a staple for remakes in Hollywood. With *Burgtheater* he is at his most tragic-ironic. Forst claimed influence from René Clair, and his stylized romantic melodramas with music tended toward period Vienna and the theme of sacrificing love for art. But not all Viennese Films were costume epics or necessarily set in Vienna. *Burgtheater* however, is the apotheosis of Forst's genre and style, a complex spiral of the art, ego and love mirroring the Goethe and Schiller plays performed on stage. A great ageing actor Mitterer (Werner Krauss) falls for a young tailor's daughter Leni (Hortense Raky) who is enamoured with Joseph (Willi Eichberger) a young theatre-hopeful. The young man's accidental invitation to a Baroness's society salon brings him fame but also scandal and it is a performance by the self-sacrificing star actor that saves his life and unites the young couple. Forst underscores the performances off stage and the truths under the art on stage. The nexus of the film is the scene at the back entrance to the theatre building (opened in 1888) in which Joseph, believing he has found his fated future, abandons Leni (who arranged for his introduction by stealing an invitation) for the fame the Baroness (Olga Tschechowa) might bring him, and Mitterer believes she has come for him alone. **⊷Robert Dassanowsky**

Directed by Willi Forst
Scene description: The theatre of life and love – on and off stage
Timecode for scene: 0:47:30 – 0:49:15

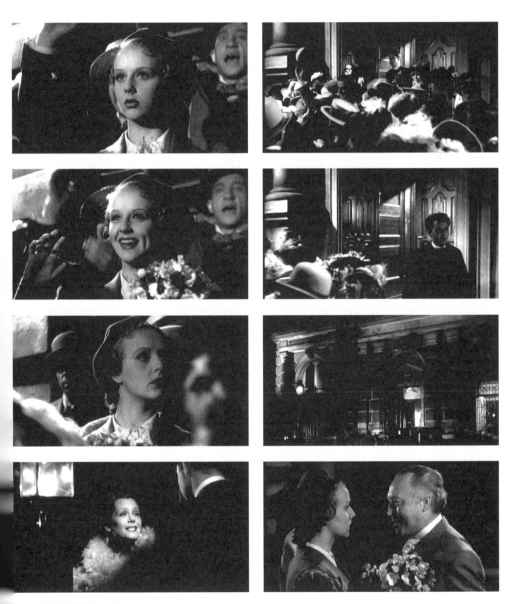

OPERETTA/OPERETTE (1940)

LOCATION *Theater an der Wien interiors, Linke Wienzeile 6, 6th District*

OPERETTE IS THE FIRST of Willi Forst's lavish Vienna trilogy filmed during the annexation to Nazi Germany and is an attempt to underscore the cultural importance of the Viennese operetta through a semi-fictionalized history which includes composers Johann Strauss II and Franz von Suppé. Forst himself plays Franz Jauner, based on the famous nineteenth-century theatre actor and operetta director, who attains the directorship of the Theater an der Wien (Theater on the Vienna River Canal; created by Mozart librettist Emanuel Schikaneder, 1801) through the influence of operetta star Marie Geistinger (Maria Holst). After he receives the appointment letter, Jauner exclaims that he is going to a big theatre in a big city. Vienna is indeed depicted as a large metropolis, but it is not allowed to rival Berlin within the Nazi regime, even in historical portrayal. Jauner comes to direct the Carltheater, and through his occasional meetings with Marie, who tours widely, the audience learns of her secret love for him. They meet again when the married Jauner has become the head of the court opera and Marie is engaged to the Count Esterházy. Both lament that they have been unfaithful to the operetta which has bound them together. Jauner moves to the leadership of the Ringtheater, which burns down during a performance on 8 December 1881, killing 386 people. He is named responsible for the disaster and serves a three month prison sentence. Although the film has a happy ending with the audience cheering Jauner's return to operetta as he recalls Marie's presence in his life, the historical Jauner committed suicide in 1900 following the discovery of the bankruptcy of the Carltheater (damaged in bombing 1944; demolished 1951). **➙Joseph W. Moser**

Directed by Willi Forst
Scene description: Franz Jauner arrives in
Vienna, the future capital of Operetta
Timecode for scene: 0:18:00 – 0:20:24

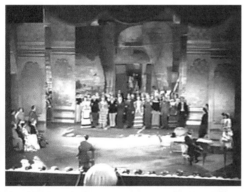

THE THIRD MAN (1949)

Josefsplatz, 1st District

MORE THAN A FEW of today's travellers to Vienna hope to retrace the steps of *The Third Man*. Vienna does not disappoint. A Third Man walking tour, weekly screenings at a Ringstrasse movie theatre and a dedicated museum, all meet the popular demand to experience the city through the film and its hero Harry Lime (Orson Welles). For if Mozart is the classic face of Viennese high culture, Harry Lime is his iconic modern twin, a figure around which Vienna is repackaged as a site of popular film culture. Spiritual adviser to generations of Harry Lime stalkers, Holly Martins (Joseph Cotten) is looking for Lime from the moment he arrives at the train station. But as Martins soon learns from Lime's house porter (Paul Hörbiger), his old school friend is dead, killed by a truck in the street. Disappointed, but roused by adversity and a beautiful woman, Martins receives a call. 'Baron' Kurtz (Ernst Deutsch) offers Martins a walking tour of the accident site. *The Third Man* is celebrated for its expressive use of locations damaged by wartime bombings. But the Josefsplatz survived the war and the sequences shot there radiate the charisma of a square architecturally complete since 1783. The later equestrian statue of Emperor Joseph II occupies its centre, while the Palais Pallavicini is situated directly across it. Martins is led to perhaps the loveliest square in all Vienna. It's a seduction scene. Martins succumbs. But who can say that they have not fallen for a good Viennese story dispensed as truth? Harry Lime rose again, only to be betrayed unto death by his friend. And he is still worshipped today. Poor Harry, poor Holly. Lucky us. ↠*Michael Burri*

(Photo © Austrian National Library)

Directed by Carol Reed

Scene description: 'And this is where he died.' Kurtz tells the story of Harry Lime's death to Holly Martins

Timecode for scene: 0:14:58 – 0:17:58

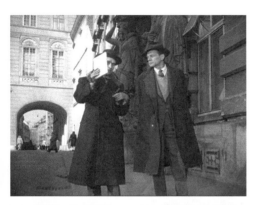
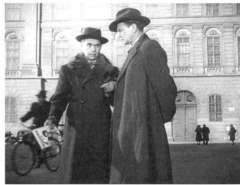
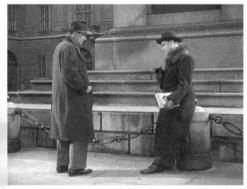
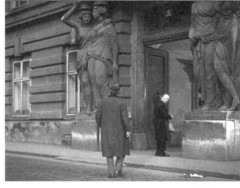
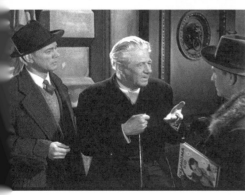

THE RED DANUBE (1949)

LOCATION *Aspang Train Station, 3rd District*

IT'S 1945. BRITISH COLONEL NICOBAR (Walter Pidgeon) and his staff receive an order to assist the Russian allies by handing over for repatriation war refugees, or Displaced Persons, living in the British zone, who are former citizens of the Soviet Union. A suicide by a Russian physicist, who chooses death over Moscow, and the broken heart of his Major McPhimister (Peter Lawford) show Colonel Nicobar that the Russians and the British are not paddling in the same direction. Life is not merry movement when movement is not a choice but a compulsion. Vienna is a place of arrival and departure. Colonel Nicobar must hand Maria Bühlen (Janet Leigh), a Volga German and the love object of Major McPhimister, over to the Russians. Time passes. It is late Christmas Eve. Billeted in a convent, Colonel Nicobar debates with the Reverend Mother Auxilia (Ethel Barrymore) the relevance of God and church in a war-addled world. The telephone rings. The Russians have delivered a trainload of refugees to Aspang Train Station in the British zone to which the Colonel must attend. Among the refugees is Maria Bühlen, who has escaped and returned. It is an arrival that cannot help but recall a series of fateful late-night Vienna departures only a few years before. Beginning in February 1941, the first of 45 trains, altogether carrying roughly 50,000 Jewish citizens, left Aspang Train Station for incarceration, suffering and death. Decommissioned in 1971, a gesture that tacitly acknowledged its place in Viennese history, Aspang Train Station is, in 2012, an urban ruin that awaits redevelopment. A small memorial designates the site as the 'Place of the Victims of Deportation'. **↝Michael Burri**

Directed by George Sidney
Scene description: The Colonel decides the fate of a trainload
of Cold War refugees en route to the Soviet Union
Timecode for scene: 1:12:08 – 1:16:10

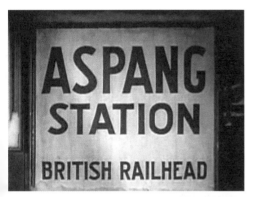
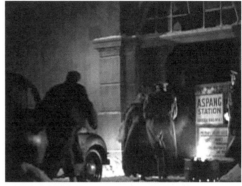
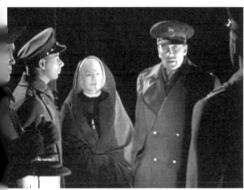
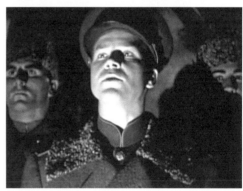
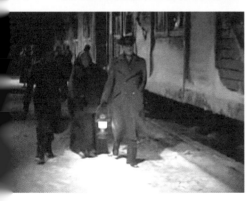

FOUR IN A JEEP/
DIE VIER IM JEEP (1951)

LOCATION *Neue Burg (New Castle wing),*
Hofburg Palace and Ringstrasse, 1st District

IN THIS SWISS PRODUCTION directed by the Vienna-born Leopold Lindtberg, Vienna functions as an integral site for the unfolding of post-war events. Entangled in Cold War intrigue, a young Viennese woman, Franziska, is to be apprehended by the Russians, because her husband has escaped Soviet captivity. The Soviets have no jurisdiction over Franziska, however, since she resides in the French sector of the city. The title of the film refers to the military patrols (made up of one soldier from each Allied power) which kept watch over Vienna's city centre. Interactions among the characters representing the four powers illustrate the conflicts developing among the Allies, particularly between the Soviets and their western Allies, as well as the Allies' differing attitudes towards the locals. When the patrol is sent to investigate Franziska's arrest, its jeep heads onto the Ringstrasse, the grand boulevard built as a showcase of the Austrian Empire and now encircling what has become the post-war international sector. We see the four flags of the Allies on the hood of a jeep and then the soldiers in their respective uniforms, speaking a mixture of their languages, as they drive past (in rear projection) the historical buildings of government and culture. This post-war panorama underscores Vienna's distressed situation as the capital of a once powerful empire now under total control of foreign powers. The term 'four in a jeep' has since come to refer to this period of Vienna's occupation. •◦**Mary Wauchope**

Directed by Leopold Lindtberg
**Scene description: A divided Vienna
and a forbidden Cold War marriage**
Timecode for scene: 0:04:54 – 0:05:53

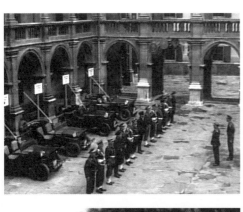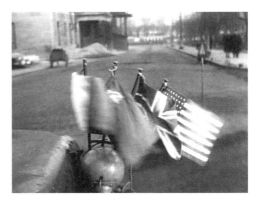

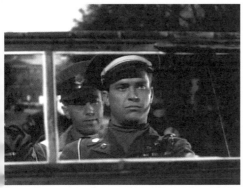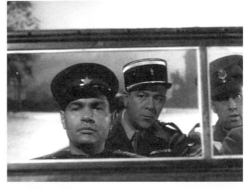

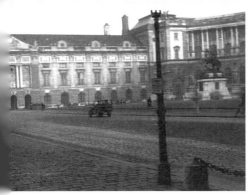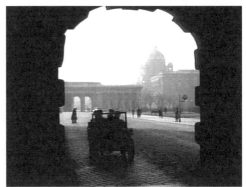

ADVENTURE IN VIENNA/
ABENTEUER IN WIEN (1952)

LOCATION

Vienna International Airport, in Schwechat, south-east of Vienna

'HOME IS WHERE YOU COME when you run out of places,' snarls Barbara Stanwyck in *Clash By Night* (1952) directed by the great, Vienna-born Fritz Lang. For taxi driver Toni Sponer (Gustav Fröhlich), there is no home. Stateless and without identity papers, like so many in post-war Vienna, he wants out. But how? The young Fröhlich played in Lang's *Metropolis*, the 1927 dystopian classic about the perils of technology, capitalism and bad parenting. But that urban inferno has nothing on the Vienna of *Adventure in Vienna*. Walking towards a British Airways plane at what was called Schwechat Airport, Toni Sponer takes the final steps of a hellish journey that began earlier that evening when he picked up John Milton, an American, at the Western Train Station. Just arrived, Milton intends to rescue his childhood friend Karin Manelli (Cornell Borchers) from her obsessively jealous husband Claude Manelli (Francis Lederer) and jet her back to New York. Milton, however, won't need the return ticket. Finding him shot dead in the rear of his cab, Sponer quickly decides to fly in his place – a move that puts him on a collision course with the police, Karin Manelli, the unknown murderer, and, in his mad rush to the departure gate, the city itself. Airports evoke optimism, progress, and modernity. Inspired by film noir and an expression of the pessimistic outlook of post-war occupied Austria, *Adventure in Vienna* questions these values. Schwechat, like the Vienna of the film, is a hostile labyrinth, more darkness than landmark. The final scene is a late-night showdown on a cold and open runway field. They are all there – Sponer, Karin, the police, the murderer. And as perhaps at every airport, a touch of *Casablanca* is present. **⇢Michael Burri**

Directed by Emil E. Reinert
**Scene description: A plane is leaving Vienna
and Toni Sponer makes a fateful decision**
Timecode for scene: 1:19:05 – 1:25:38

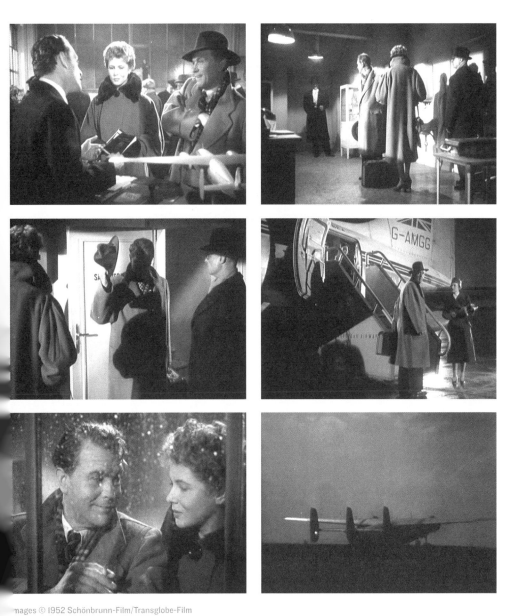

APRIL 1, 2000/
I. APRIL 2000 (1952)

Schönbrunn Palace Park, 13th District

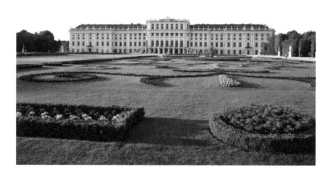

MADE IN 1952, this all-star science fiction/satire is set half a century in the future. It was sponsored by the Austrian government to argue the case that the still Allied occupied Austria should become an independent nation again. In the film, Austria is still administered by these powers in the year 2000. When a newly-elected prime minister (Josef Meinrad) calls on all citizens to tear up their occupation identity cards, the futuristic world organization, the Global Union, sends a commission to determine if the Austrian people have become a threat to world peace. Judges arrive in a flying saucer, which lands ominously and incongruously in the entry courtyard of the baroque/neoclassical Schönbrunn Palace and Gardens, the former Habsburg summer residence, created by Empress Maria Theresa between 1743 and 1775. Comparable to Versailles, Vienna's most-visited tourist attraction and an important symbol of Austria's imperial past, Schönbrunn is certainly a meaning-laden site for Austria 'on trial'. The Global Union ultimately awards Austria its sovereignty after a pageant-like review of its history and culture – which focuses on imperial Austria and stops before World War I – convinces the court that the Austrians are a benevolent and peace-loving people; one juror laments they have been stabbed in the back with 'Viennese Gemütlichkeit (conviviality)'. With reference to a historic couplet which refers to the diplomatic traditions of the Austrian Empire – 'Let others wage war, but thou, O happy Austria, marry' – the film ends with the Austrian prime minister ensuring Austria's contribution to world peace by marrying the head of the Global Union (Hilde Krahl). As a setting for a more realistic encouragement of world peace, Schönbrunn Palace was utilized as the site of the Kennedy-Khrushchev summit dinner in 1961. **⤳Mary Wauchope**

Directed by Wolfgang Liebeneiner
Scene description: The futuristic World Global Union
arrives in its flying saucer to judge Austria
Timecode for scene: 0:14:32 – 0:18:41

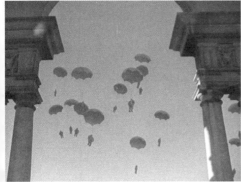

SISSI (1955)

LOCATION *St Michael's Cathedral, Michaelerplatz (Michael's Square), 1st District*

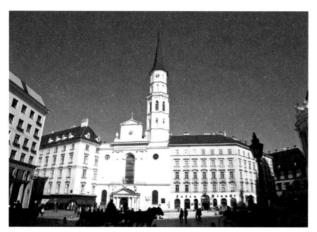

OF ALL THE MOVIES produced in post-war Austria the three *Sissi* films were by far the most popular. These films depict the love affair and marriage between the young Elisabeth of Wittelsbach (the star-making role for Romy Schneider) and the Emperor Franz Joseph (Karlheinz Böhm). The first film in the trilogy, *Sissi*, was made in 1955, the year of the signing of the first post-fascist Austrian constitution (*Staatsvertrag*). It signals a moment of conscious self-fashioning on the part of the Austrians following the defeat of fascism and the occupation of Vienna by Allied forces. Marischka's film re-imagines this imperial marriage as something that might still marshal national pride in Austrian history. The wedding scene was filmed on location at the fourteenth-century Romanesque St Michael's Church, a church whose interior was rebuilt in baroque style in the eighteenth century. The actual wedding took place at the less opulent, fourteenth-century gothic St Augustin's Church, parish church for the imperial family, located just around the corner at the Hofburg complex. The procession clocks in at a whopping six minutes and there is no dialogue, save for a few excited utterances on the part of the onlookers. The sequence editing stretches the time of the procession: Sissi's carriage is depicted passing spectators again and again; Franz Joseph slowly makes his way up the red carpet to the altar via cuts that actually extend the time of his journey. This temporal stretching invites both a nostalgic desire to return to the imagined utopia of the Habsburg Empire and a wish to simply stop time, to languish in the baroque spectacle and to slow the approach of an unknown future. **•❖ Heidi Schlipphacke**

Directed by Ernst Marischka
Scene description: The wedding procession of the imperial couple
Timecode for scene: 1:39:49 – 1:45:16

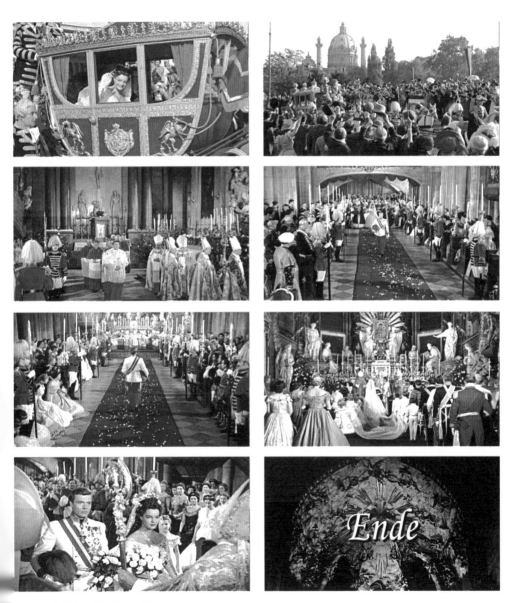

THE JEWISH TOPOGRAPHY OF FILMIC VIENNA

Text by DAGMAR C. G. LORENZ

SPOTLIGHT

VIENNA WITH ITS RICH Jewish history and its location at the crossroads between East and West, North and South, has inspired international films with themes and protagonists. Jewish film-makers and actors have continued to film in Vienna, even after the Holocaust. The Jewish topography of filmic Vienna largely coincides with the paradigms of Jewish settlement and Jewish memory. In early-twentieth-century Vienna there was not just one single Jewish neighbourhood, but Jews lived in and frequented different areas. 'Jewish Vienna' comprises parts of the inner city, of the Second District, Leopoldstadt, the university and medical district of Alsergrund, and the modest Josefsstadt. Since the era of silent movies Austrian film was informed by literary paradigms and a Jewish topography, co-territorial, but not identical with Catholic Vienna, that had been established in the literary works of Peter Altenberg, Arthur Schnitzler and Hugo Bettauer, and in the films inspired by them.

Jewish authors and film-makers typically viewed Vienna from an off-centre perspective

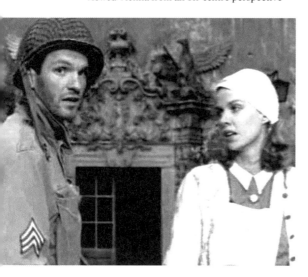

that confirmed as well as qualified notions of co-territoriality. *Die Stadt ohne Juden/The City without Jews* (H. K. Breslauer, 1924) and *Die freudlose Gasse/The Joyless Street* (G. W. Pabst, 1925), both based on novels by Hugo Bettauer, include Jewish-identified characters in their social portraits of inter-war Vienna. The metropolis 'Utopia', the setting of *The City without Jews*, a centre of commerce and a playground for the urban Jewish population, is modelled after Bettauer's Vienna. When an anti-Semitic government expels the Jewish population, the city loses its wealth and international flair as it loses the Jewish patrons of the arts, restaurants and coffeehouses. Breslauer's film shows the palais and luxury apartments of the Jewish elite and the splendid interior of the synagogue, as well as the slums and the dire living conditions of unassimilated poor Jews, whom the audience would imagine to live in the immigration district of Leopoldstadt. The mass exodus of poor Jews is contrasted with petty bourgeois Christmas celebrations and reveals the precarious Jewish condition. Jewish uprootedness continues to be an issue in *Welcome in Vienna* (Axel Corti, 1986). The film introduces an Austrian-Jewish exile returning to Vienna as an American GI at the war's end and again facing anti-Semitism.

The films of Hanus, Niernberger and Löwenstein documented the economic hardships affecting inter-war Vienna along with rising criminality and moral decline. Such critical works often had a Jewish subtext as did the social critical *The Joyless Street*. This Berlin studio produced film has Vienna as its setting and constructs a dichotomy between rich and poor, exploiters and exploited, Viennese citizens and foreigners. A nightclub owned by the procuress Greifer located in the blighted Melchiorgasse – the name calls to mind an actual side street in Vienna's Second District – figures as the erotic hunting ground for Americans and

Opposite © 1986 Schweizer Fernsehen
Above © 2002 EEXTRA-Film Arbeitsgemeinschaft Film & Video GmH

speculators like Max Rosenow marked as Jewish by his foreign appearance, Slavic name, and a dissolute lifestyle matching common anti-Semitic stereotypes.

After 1945 the motif of corrupt Vienna was taken up in *The Third Man* (Carol Reed, 1949) showing shady local and international characters conducting illicit transactions among the ruins with locations in the inner city (1st District) and Leopoldstadt. Kurtz, a sexually ambivalent profiteer played by Austrian-Jewish actor Ernst Deutsch perpetuates negative Jewish stereotypes. He is associated with coffeehouses and nightclubs such as the actual Casanova Club in the Dorotheergasse and places in the former Jewish textile quarter. Kurtz lives at Morzinplatz near the ruins of the Hotel Metropole, the former Gestapo headquarters destroyed in the war. The black marketeer Harry Lime also participates in the Jewish subtext through his association with Jewish characters. The location of his apartment is uncertain, but he appears at Jewish-identified sites: Judenplatz, Tiefer Graben and Am Hof, where the medieval ghetto was located. He also is placed at the Reichsbrücke, the Empire Bridge, connecting the Leopoldstadt, site of the Prater and the Ferris Wheel as well as the second Vienna ghetto, to the Danube Island.

In post-Shoah film, the Second District or Leopoldstadt, the eastern part of the inner city sloping toward the Danube Canal, and the Jewish section of the Zentralfriedhof (Central Cemetery), represent sites of Jewish memory and re-emerging Jewish life. The back-ended area around the Stadttempel (City Synagogue) in the Seittenstettengasse, stretching down to the Franz Josef-Kai (Franz Joseph Quay) is dubbed 'the Bermuda Triangle' because of its shape and ever-changing nightlife. This location, among others, is featured in the path-breaking film about Jews, Austrians and Germans in 1970s Vienna, *Kieselsteine/Pebbles* (Lukas Stepanik, 1983). The contrast between the quiet nineteenth-century facade and the foyer of the synagogue where conservative Jews gather for a memorial service alongside the boisterous nightlife nearby captures the perplexity of post-Shoah Jewish life. Like *Pebbles*, the documentary films of Ruth Beckermann, *Wien Retour/Return to Vienna* (1983) and *Die Papierene Brücke/The Paper Bridge* (1987), avoid shots of the many Christian sites.

In contemporary filmic Vienna, the Second District has retained its significance as a neighbourhood shaped by the Jewish experience. The Prater Ferris Wheel and the central train station Praterstern, the old Nordbahnhof (North Station), represent the key sites within inter-war Jewish Vienna as re-constructed in Beckermann's *Return to Vienna*. Remembering 'Red' (i.e. 1920s Socialist) Vienna, Beckermann's interviewee Franz Weintraub West notes that the density of the Jewish population in the Leopoldstadt made for a modicum of safety for newcomers, but it also provoked anti-Semitic attacks. The utilization of the Webergasse in the Second District as the home of the ill-fated fictitious Jewish-Gentile couple in *'38 – Auch das war Wien/'38 – Vienna Before the Fall* (Wolfgang Glück, 1986), suggests that before the Nazi German invasion, the potential for diversity and privacy did exist there.

Associated with the memory of Vienna's pre-war Jewish communities and the extreme brutality of their destruction in 1938 caused the Danube Canal to be viewed as a dividing line and Leopoldstadt as a site to be avoided. In *Return to Vienna* the period photograph of the Praterstern is framed as a memento of a lost world. Contemporary films such as *Gebürtig/Gebirtig* (Lukas Stepanik and Robert Schindel, 2002) cast these history-laden sites into meeting places for Jews and non-Jews. For example, Schindel's Jewish protagonist and his gentile girlfriend explore each other's feelings during a walk in the Prater. ✛

Jewish authors and film-makers typically viewed Vienna from an off-centre perspective that confirmed as well as qualified notions of co-territoriality.

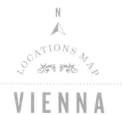

LOCATIONS MAP

VIENNA

maps are only to be taken as approximates

17 Döbling

23

Floridsdorf

Währing

Brigittenau

Donaustadt
(north)

Hernals

24

Ottakring

Penzing

Leopoldstadt

21 20 19

Rudolfsheim

Neubau

Innere Stadt
(center)

Prater

22

Wieden

18

Landstrasse

Hietzing

Schloss
Schönbrunn

Favoriten

VIENNA LOCATIONS
SCENES 17-24

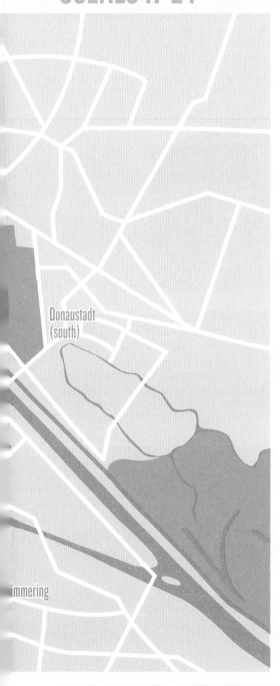

17.
VIENNA, CITY OF MY DREAMS/
WIEN, DU STADT MEINER TRÄUME (1957)
'Heurigen' – The Wine Taverns,
19th District (Grinzing/Döbling)
page 52

18.
SONG WITHOUT END (1960)
Schlosstheater (Palace Theater),
Schloss Schönbrunn, Schönbrunner
Schloßstrasse 47-49, 13th District
page 54

19.
THE CARDINAL (1963)
St Stephan's Cathedral, Stephansplatz
and Erzbischöfliches Palais (Archbishop's
Palace), Wollzeile 2, 1st District
page 56

20.
MIRACLE OF THE WHITE STALLIONS (1963)
Spanish Riding School Tract,
Hofburg Palace Complex, 1st District
page 58

21.
MAYERLING (1968)
In der Burg (Interior Courtyard and inside
the Chancellery Wing), Hofburg Palace
Complex, 1st District
page 60

22.
SCORPIO (1973)
Karlsplatz (Charles's Square), 4th District
page 62

23.
THE NIGHT PORTER/
IL PORTIERE DI NOTTE (1974)
Karl-Marx-Hof (Karl Marx Court),
Heiligenstädter Strasse 82-92, 19th District
page 64

24.
JESUS OF OTTAKRING/
JESUS VON OTTAKRING (1976)
Comeniusgasse 8, 17th District
page 66

VIENNA, CITY OF MY DREAMS/
WIEN, DU STADT MEINER TRÄUME (1957)

LOCATION *'Heurigen' – The Wine Taverns, 19th District (Grinzing/Döbling)*

LIKE THE FAMED *Wienerlied/Viennese song* by Rudolf Sieczynski (composed 1912) after which it is named, this film provides a nostalgic look back at Vienna and its traditions. In the film, the king (Hans Holt) of a fictional country, Alania, visits Vienna with his daughter (Erika Remberg). Because he has always spoken so enthusiastically of the city where he spent his student days, Vienna has become the daughter's 'city of dreams'. From the opening scenes of the city from the air, the film shows Vienna in all its romantic glory. After a guided tour of Vienna's famous attractions, the highlight of the king's visit takes place in a *Heuriger* in Grinzing. These taverns serve the new wines of each year, accompanied by traditional music and an ambience of *Gemütlichkeit*. At the *Heuriger* the king argues with his newfound love interest, a modern sculptress, about the values of the old versus the new in Viennese life. Images depicting the camaraderie of guests sitting at tables under a full moon and the charm of an elderly gentleman singing in Viennese dialect to the accompaniment of traditional musicians firmly decide the debate in favour of tradition. While in Vienna the king learns he has been deposed, but his country cannot seem to exist without links to their past either and he is ultimately asked to return as president. This film is the last to be made by legendary director Willi Forst, who lamented upon retiring that his traditional Viennese Film style was going out of fashion, a sentiment which must certainly have influenced the fond, sentimental look at Vienna.
↝Mary Wauchope

Scene description: A foreign king shows his daughter the Vienna he remembers
Timecode for scene: 0:52:14 – 1:00:15

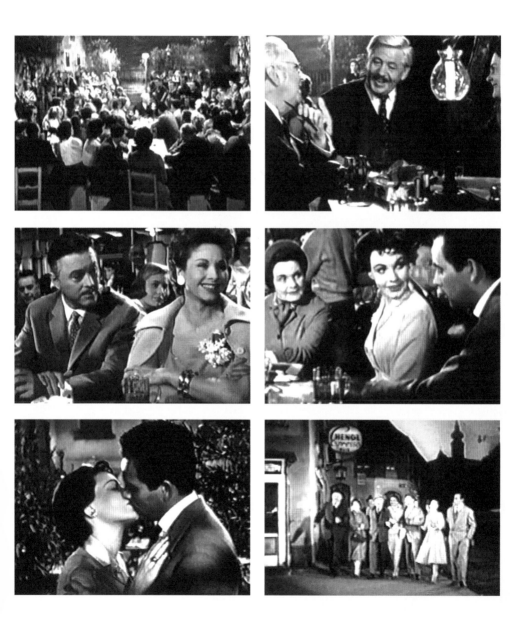

SONG WITHOUT END (1960)

LOCATION

Schlosstheater (Palace Theater), Schloss Schönbrunn,
Schönbrunner Schloßstrasse 47-49, 13th District

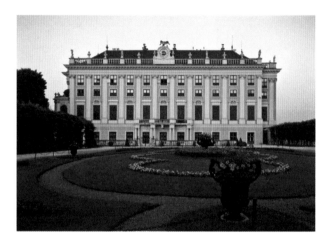

THIS BIOPIC ON Hungarian piano virtuoso and composer Franz Liszt is
visually stunning and emotionally stunting. Veteran director Charles Vidor died
during the filming and was replaced by George Cukor who was frustrated in
his attempt to rewrite the script. The depiction of this brilliant and charismatic
composer who finds himself torn between womanizing, a hunger for audience
adulation and riches, and devotion to Catholicism is superficial. Supporting the
miscast Dirk Bogarde as Liszt (concert pianist Jorge Bolet provides the actual
performances) are Geneviève Page as Countess Marie d'Agoult, who suffers
scandal and neglect as the mother of his illegitimate children, and Capucine
as Liszt's adoring mentor, Russian Princess Carolyne Sayn-Wittgenstein, who
gives up both husband and fortune for him. The film features almost forty
compositions by Liszt and other composers, but little is conveyed about Liszt's
musical philosophy and his artistic relationship with Wagner is absurdly
caricaturish. Nevertheless, the film earned a Golden Globe and an Oscar. The
project shows an uneasy transition between traditional studio production and
the on-location epics later in the decade. With few exterior shots the film has
the feel of lavish sound stage design, but much of its impressive production
values are created by the use of historical theatre, church and palace interiors
in Austria – with Vienna sites doubling for Paris, St Petersburg, Kiev, Dresden,
Weimar, Odessa and Rome. A tribute to the architectural diversity of the
city, certainly, but Liszt's performance in Vienna for Emperor Ferdinand and
Empress Maria Anna in a benefit for victims of a Hungarian flood (one of
many in the 'Liszt-mad' city between 18 April and 25 May 1838) is an attempt
at authenticity and is shot at the exquisite rococo Schlosstheater (designed by
Nikolaus Pacassi; opened 1747) of Schönbrunn Palace. **➡️Robert Dassanowsky**

Directed by Charles Vidor and George Cukor
Scene description: Pianist Franz Liszt
performs for his devoted fans in Vienna
Timecode for scene: 0:25:52 – 0:30:51

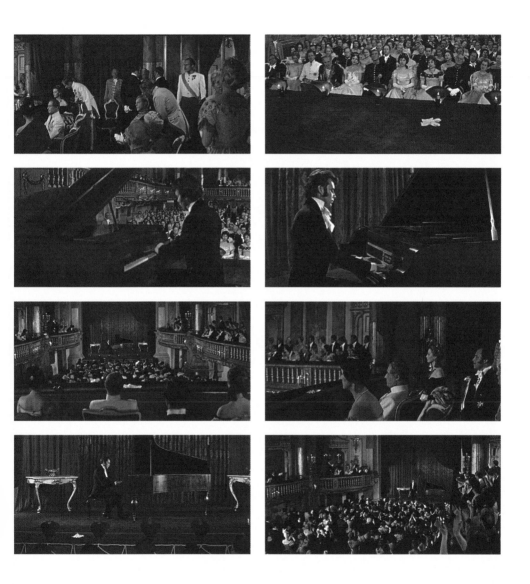

THE CARDINAL (1963)

LOCATION *St Stephan's Cathedral, Stephansplatz and Erzbischöfliches Palais (Archbishop's Palace), Wollzeile 2, 1st District*

VIENNESE-HOLLYWOOD director/producer Otto Preminger, who had shot his first film *Die grosse Liebe/The Great Love* in Vienna in 1931, returned there three decades later to film his second, which follows a fictional Boston priest Stephen Fermoyle (Thomas Tryon) as he rises in the Church hierarchy. Fermoyle's trip to Vienna in 1938 to shut down the Papal Nunciature upon the annexation of Austria to Nazi Germany, allows Preminger to recreate historical events. He attempts to convince Vienna's charming but unyielding Cardinal Theodor Innitzer (Josef Meinrad) to stop promoting the Anschluss in order to secure the future of the Church, but it is not until his meeting with Hitler that Innitzer realizes his fatal error. He addresses a group of Catholic Youth that assemble around the Cathedral that night. In response, they hold a prayer vigil with opera star Wilma Lipp leading the group in the *Alleluia* from Mozart's *Exsultate Jubilate*. Attacked by a large mob of Storm Troopers and Hitler Youth, the police instead arrest the Catholic Youth for creating the disturbance. The Nazi mob breaks into the Archbishop's palace, smashing statuary, breaking furniture, and slashing a painting of the Crucifixion (which still hangs in the building as reminder). Ultimately they push a priest out a window to his death. This violent sequence is Preminger's ultimate antidote to the image of a romantic inter-war Vienna which appears earlier during Fermoyle's 1924 sabbatical from the priesthood and his near love affair with student Annemarie (Romy Schneider). In 1938, Fermoyle discovers that she too has become a victim of the regime she welcomed. It is a unique and moving Hollywood representation of the brutality that came with the Anschluss.
↪Robert Dassanowsky

Scene description: Nazi mob attacks Catholic Youth group and defiles Archbishop's Residence at the Anschluss in 1938
Timecode for scene: 2:42:48 – 2:51:08

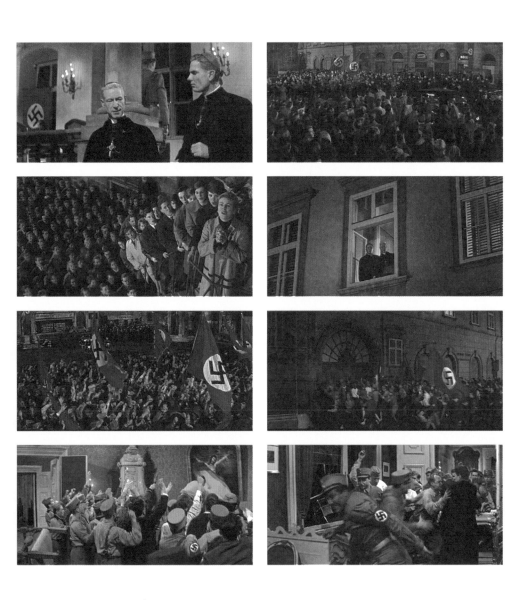

MIRACLE OF THE WHITE STALLIONS (1963)

LOCATION *Spanish Riding School Tract, Hofburg Palace Complex, 1st District*

BASED ON THE MEMOIR by Olympic rider and long-time director of the Spanish Riding School, Alois Podhajsky, this blend of docudrama and melodrama details how he (Robert Taylor) and his wife (Lilli Palmer) managed to save the prized Lippizan stallions from the Allied bombing of Vienna and Soviet occupation (suggested to be a barbarism equal to Nazism) in the spring of 1945. With the help of a sympathetic German general (Curd Jurgens) and those who re-identify themselves as 'Austrian', the horses are moved at great peril to a country estate that becomes part of the US occupation zone. The equestrian General Patton is convinced to send his 'Cowboys' into Czechoslovakia and rescue the mares, POWs, and some surrendering Germans from remaining SS units and the approaching Soviets. It is the most cultural-political Disney film from the era of the studio's productions in Vienna, and often goes beyond the work it obviously visually influenced, the 1965 non-Disney *Sound of Music*. There is talk of concentration camps, the assassination attempt on Hitler, and fear of the new 'conquerors'; a performance of Mendelssohn's 'forbidden' music leads to discussions on the value of art and tradition, and a compassionate Countess Arco-Valley (Brigitte Horney) cares for hundreds of refugees. Although Nazism remains unexplored, and the comically doltish American GIs are said to comprehend the value of European art, the final sequence in 1955 which features a performance of the Lippizans in the restored hall of the Spanish Riding School at the Hofburg Palace is a love letter to Vienna. ↝**Robert Dassanowsky**

Directed by Arthur Hiller
Scene description: The rescued Lippizan horses perform
in Vienna on the return of Austrian sovereignty
Timecode for scene: 1:46:01 – 1:57:40

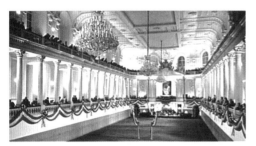
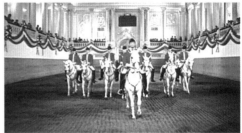
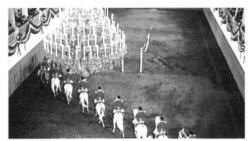
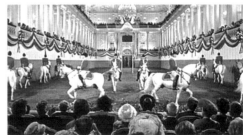

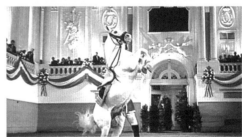
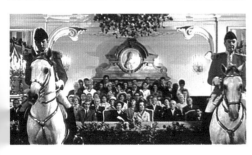

MAYERLING (1968)

LOCATION *In der Burg (Interior Courtyard and inside the Chancellery Wing), Hofburg Palace Complex, 1st District*

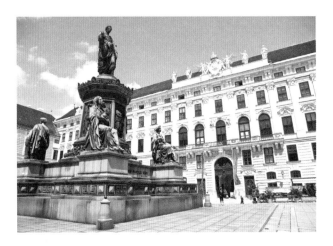

THE 1968 MAYERLING FILM is less a remake of the 1936 Charles Boyer romance than an attempt to set a 'dream cast' against opulent historical settings and spice the visual pleasure with trendy notions regarding a tragic generation gap between the long-reigning Emperor Franz Joseph (James Mason) and his troubled son and heir the Archduke Rudolf (Omar Sharif). The mythic love affair between the married Archduke and the innocent Baroness Maria Vetsera (Catherine Deneuve) that resulted in a suicide pact has long been questioned, and it has been suggested that Rudolf's death was linked to his liberalism and Hungarian irredentism, or may have even been an assassination by foreign powers fearing he might eventually change Vienna's European alliances. The film emphasizes these aspects (a sympathetic Prince of Wales pays a visit) but also hints at Freud with oedipal tinges colouring the relationship between Rudolf and his mother, the Empress Elisabeth 'Sissi' (Ava Gardner). It is a violent 1960s style protest in the interior courtyard of the Hofburg Palace that launches this revisionist Habsburg saga. As Franz Joseph and his Prime Minister watch from the balcony of the Imperial Chancellery, students and their followers carry signs and wield truncheons, climb the statue of Francis II of the Holy Roman Empire, overturn carriages, and fail to fight off police guards on horseback that brutally beat and cut them. Rudolf has the rioters released from arrest and is then lectured by his father on the inappropriate political company he keeps and the mob's unacceptable protest 'against order'. Rudolf's ultimate escape into promiscuity and the ill-fated romance with Maria seems to predict a frustrated endgame for the contemporary counterculture at the same time as the film displays the positive production values of on-location shooting for costume epics in the post-studio era. **Robert Dassanowsky**

Scene description: A legendary generation gap in the Habsburg dynasty
Timecode for scene: 0:02:37 – 0:09:53

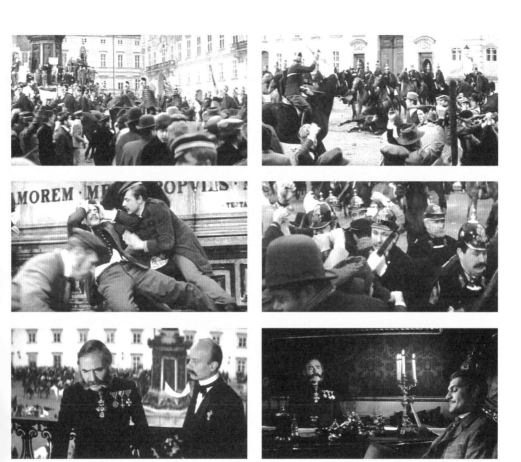

SCORPIO (1973)

Karlsplatz (Charles's Square), 4th District

THE ESPIONAGE GAME is like the Hotel California. Once inside, it's difficult to really leave. Master spy Gerald Cross (Burt Lancaster) wants out, and so his CIA handlers want him dead. They approach Scorpio (Alain Delon), a young protégé of Cross. Scorpio refuses, but relents when it is agreed that he will become Cross's successor at the Beirut posting. Cross flees Washington – but where? An agency department head provides the outlines, 'A former picnic ground, not too east and not too west.' *Scorpio* stages its showpiece action sequence at Karlsplatz. Like Vienna itself, the Karlsplatz is a border zone. And as at all borders, extremes meet. On the horizontal axis, Karlsplatz is situated between the former city fortifications and the suburban periphery. On the vertical axis, the square's surface is located on the former riverbank of the Vienna River, which since the park's reconstruction (1895–1902), flows in a subterranean channel. At the square's southeastern corner is the Karlskirche (St Charles Church), the most significant sacral baroque construction in Vienna, while only a few feet away is the Resselpark, once home to the black market. Under reconstruction for the metro station located there today, Karlsplatz is the ideal location for a spy situated at the border between east and west, life and death, loyalty and betrayal. Kim Philby, the legendarily elusive British spy, cast his fate with communism in Vienna while witnessing the defeat of the Austrian Left by the Austrofascist government. In *Scorpio*, Soviet agent Zharkov (Paul Scofield) hopes to turn Cross to Moscow. But Cross is already converted, a double-agent. Like Karlsplatz, he is on the margin, a soldier in no man's land, neither here nor there. **Michael Burri**

Directed by Michael Winner

Scene description: A Cold War spy chase ends at the
metro construction site on the historical Karlsplatz
Timecode for scene: 1:15:01 – 1: 22:07

 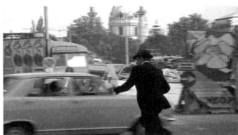

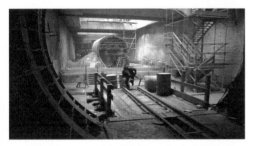

 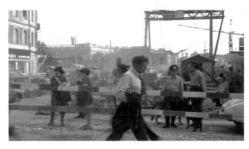

THE NIGHT PORTER/
IL PORTIERE DI NOTTE (1974)

LOCATION *Karl-Marx-Hof (Karl Marx Court),*
Heiligenstädter Strasse 82-92, 19th District

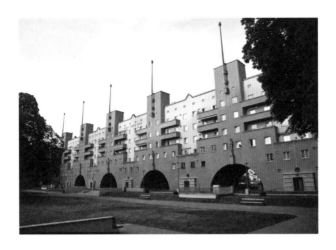

THE MELODRAMA OF SS officer Max Aldorfer (Dirk Bogarde) and his
concentration camp prisoner Lucia (Charlotte Rampling) revisiting their
original sadomasochistic affair when they accidentally meet in 1957 Vienna
remains provocative for embracing a taboo and influencing Nazisploitation
films to follow. The grey toned cinematography washes the baroque of Vienna
in melancholy and the cuts between a troubled present, a performance of
Mozart's sublime *Magic Flute*, and the raw assault of Holocaust memory
suggest the layers of the city's past and the unseen that also defines it. Cavani
begins her Visconti-like decadence by following Max as he walks through
Vienna's past into the present – the monumental dual museums facing the
Empress Maria Theresa monument; the *fin de siècle* Secession Museum; a
banal street of shops. She ends the film with the couple's murder on a faceless
metal bridge. His utilitarian apartment in the sprawling Karl-Marx-Hof is a
stark contrast to the bourgeois elegance of the hotel where he works and hides.
The first planned progressive housing complex on the continent, it is among
the longest residential buildings (1,382 units, offices, shops, clinics and cafes),
and a major emblem of the 'Red Vienna' period of the 1920s. The sparingly
ornamented fortress by Karl Ehn is as stunning as any of the city's imperial
edifices. By housing a Nazi in the structure that was a socialist stronghold
during Austria's brief civil war (1934) and was anathema to the Nazi regime
(1938–45), Cavani articulates far more political criticism than with the film's
infamous SS erotic-shock scenes. It is in this proletarian paradise that Max
is ultimately trapped and where the couple self-destructs. Cavani's film is not
only about human bodies and gruesome role playing, but about the bodies of a
city and the palimpsest of its identities. **•Robert Dassanowsky**

Scene description: The haunted Nazi, his former victim,
a perverse romance and an iconic building
Timecode for scene: 1:34:23 – 1:57:21

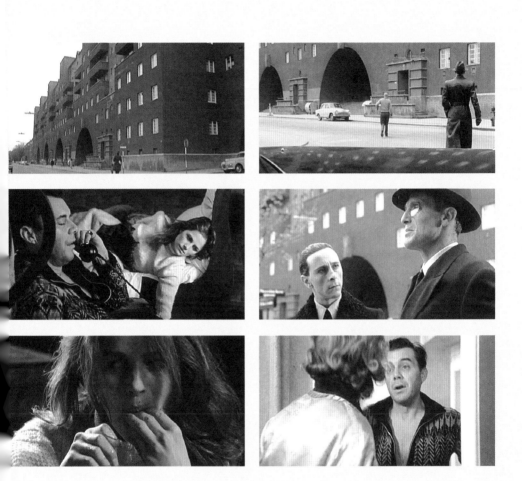

JESUS OF OTTAKRING/
JESUS VON OTTAKRING (1976)

LOCATION *Comeniusgasse 8, 17th District*

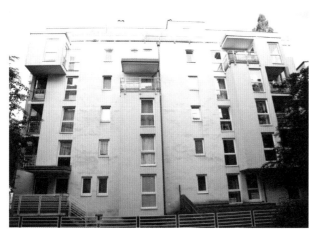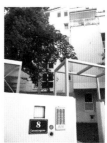

THE OUTER DISTRICTS of Vienna hold a place in the Viennese psyche nearly equal to the majestic First District and St Stephen's Cathedral. After all, St Stephen's and Vienna's many other cultural icons may cast a cosmopolitan glow over the city, but the outer districts – Döbling, Favoriten, Ottakring and beyond – serve as the vital source of local character types, language, and attitudes long cherished by the Viennese. The film tells the story of Ferdinand Novacek, a homeless man with Ottakring roots, whose Christ-like preaching unsettles the traditional working-class neighbourhood. The district's youth sympathize with the prophet and enrage their parents by supporting him. Leprecht (Peter Hey), the owner of a large-scale bakery, turns the prophet's mild labour activism into an opportunity to brand the discontent of his workers as 'terrorist'. More perplexing are the established working-class Ottakring families who live in a communal apartment building (actually shot in the neighboring district of Hernals). Led by a retired military officer (Rudolf Prack), they instinctively reject the homegrown prophet who preaches social justice. A manhunt, in which all building residents participate, ensues. Finding Jesus-Novacek in a courtyard wash house, they collectively beat him to death. Ottakring still being Vienna, however, owners and workers soon gather in the courtyard to dedicate a monument in his memory. Opening with a melancholy meditation on Ottakring's communal apartment buildings, much of its action takes place inside the residential spaces of the district's working-class heroes. The Ottakring Jesus fares little better than his namesake and the film's anthem ironically intones: 'Okay, whatever. But the real Ottakring man's got his pride.' ↪ *Michael Burri*

Directed by Wilhelm Pellert
Scene description: Ottakring residents gather in the courtyard at
Comeniusgasse 8 for a plaque dedication to the 'Jesus of Ottakring'
Timecode for scene: 0:00:36 – 0:08:20

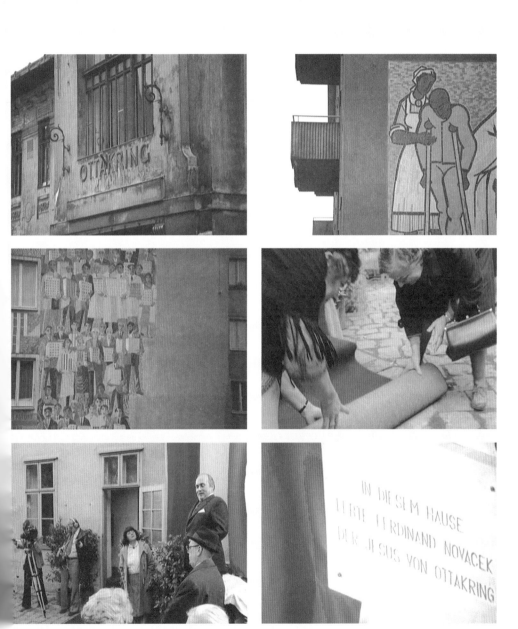

VIENNA 1945–55

Building A Post-War Identity

Text by
MARY
WAUCHOPE

VIENNA WENT THROUGH many political configurations in the first half of the twentieth century – from centre of the Austro-Hungarian Empire to capital of the much smaller First Republic of Austria, and then becoming integrated into the Third Reich – before the city was divided in 1945 into occupation sectors by the Allies. During the ten years which followed, Vienna's future role was as uncertain as was the status of Austria as a nation. Although the Allies had expressed a commitment to a post-war independent Austria, it wasn't until 1955 that they finally granted Austria status as a sovereign state, the Second Republic, with Vienna as its capital. To achieve this goal, Austrians were actively involved in demonstrating their land's readiness for independence as an economically viable and democratic country able to serve as a neutral bridge between the Cold War East and West. They aimed to demonstrate that Austrians were distinct from Germans, possessing their own common cultural traditions and national Austrian cohesion. Film played an important role in constructing and conveying a post-war image of Austrians as warranting an independent nation-state with Vienna as its undivided capital.

Some early films produced in occupied Vienna dealt with issues directly related to Austria's Third Reich past. Austria's first post-war film, *Der weite Weg/The Long Way* (Eduard Hoesch, 1946), which tells the story of a returning soldier, is both anti-war and anti-Third Reich (Austrian soldiers in the film refuse, for example, to give the Hitler salute). Another film, *Der Engel mit der Posaune/The Angel with the Trumpet* (Karl Hartl, 1948), follows a Viennese family through several generations. While the film does shy away from some post-1938 events depicted in the novel from which it is adapted, it includes the family's fanatical Nazi son and the suicide of the half-Jewish matriarch, who jumps from a window to avoid capture by the Gestapo. The majority of early post-war Austrian films, however, eschew any serious treatment of Austrian responsibility for atrocities of the Third Reich, representing instead continuity with pre-war Austrian genre film traditions of light-hearted themes and visual extravagance.

Post-war genre films frequently hark back to the grand days of the empire, highlight Austria's music legacy, or display Austria's comedic traditions. Comedies set in Vienna, like *Der Hofrat Geiger/Counsellor Geiger* (Hans Wolff, 1947), *Hallo Dienstmann/Hello Porter* (Franz Antel, 1952) and *Hallo Taxi* (Hermann Kugelstadt, 1958), starring the 'dream team' of Viennese comedy, Hans Moser and Paul Hörbiger, provide in updated settings and situations a continuity to the stereotypical Viennese humour and charm seen on screen in earlier periods. Several dramatic films also deal with life in post-war Vienna, some shot against the backdrop of war rubble or the bombed out cathedral. Biographical films, some sponsored by the Ministry of Education, brought Austrian composers to the screen, confirming Vienna's continued status as the centre of classical music: *Eroica* (Walter Kolm-Veltée, 1949), *Franz Schubert* (Walter Kolm-Veltée, 1953), *Mozart/The Life and Loves of Mozart* (Karl Hartl, 1955). Other biopics focused on figures from Austria's imperial history, for example, *Erzherzog Johanns grosse Liebe/The Archduke and the Country Girl* (Hans Schott-Schöbinger, 1950) and *Maria Theresia/Empress Maria Theresa* (Emil E. Reinert, 1951). In *Sissi* (Ernst Marischka, 1955) the 'people's empress' Elisabeth (she has in recent decades even been compared to Britain's Princess Diana) is portrayed by 17-year-old Romy Schneider with a youthfulness, vitality, and innocence which captivated post-war

have a sovereign state.

All four Allied powers recognized the value of film as an education and propaganda tool, and competition developed among them for determining the ideology of films to be made or viewed in Vienna. The western Allies transferred control of the film studios in their zones to the Austrian government early on, thereafter limiting their influence on film primarily to promoting the screening of their country's own films. The Soviets, on the other hand, had from the beginning, as ordered by Stalin himself, been committed to overseeing the development of a post-war Austrian film industry in their sector. Beginning in 1950, Vienna's largest production facility, the Rosenhügel Studio (named the 'Wien-Film' studio in 1938) began to produce films financed by the Soviet occupation forces. The propaganda function of the earliest of these films was generally limited to promoting international solidarity. The first such film was a musical called *Kind der Donau/Marika* (Georg Jacoby, 1950), whose main character works on a boat on the Danube. She sings songs in Eastern European languages, which highlights the strong cultural and historical ties between Vienna and ports further east on the Danube – ports in countries which had since become part of the Soviet Bloc. Although *Marika* was a hit throughout Europe and even showed in the United States, most Rosenhügel-made films had limited impact on the film viewers of Vienna. As the agenda for making politically engaged films at the Rosenhügel Studio intensified, so did the widespread bias against the studio because of its ties to the Soviets until 1955. As a result, films made there were regularly attacked by an anti-communist press, frequently boycotted by Austrian movie theatres, and generally poorly attended by the Austrian public. After this period, the studio passed into state ownership and regained its reputation as Vienna's leading production site under a continuation of the Wien-Film moniker into the 1980s.

cinema audiences and offered up a new iconic image for Vienna in the very year when Austria was granted it belated sovereignty.

Between 1945 and 1955 film-making in Vienna took place under the supervision of the Allied powers, and some films dealt explicitly with the city's occupied status. *Die Vier im Jeep/Four in a Jeep* (Leopold Lindtberg, 1951) countered the sinister portrayal of early Cold War Vienna, as popularized by *The Third Man* (Carol Reed, 1949) and rejected by most Viennese of the time, with a tale highlighting the difficult situation for many Viennese under Allied occupation. Another film emphasizing Vienna's position as an occupied city, *1. April 2000/April 1, 2000* (Wolfgang Liebeneiner, 1952), was commissioned by the Austrian government specifically to function as a plea to the Allied forces to grant Austria independence. In this tongue-in-cheek science fiction film set in still-occupied Vienna in the year 2000, the Austrian president must argue before the world government that Austrians deserve to

With the Allies vying for influence through film as part of a Cold War propaganda battle and Austrians in both eastern and western sectors, including the provisional government, all having a hand in bringing portrayals of Vienna to the screen, the task of projecting early post-war Viennese identities onto film proved to be both culturally and politically charged. ✤

> Between 1945 and 1955 film-making in Vienna took place under the supervision of the Allied powers, and some films dealt explicitly with the city's occupied status.

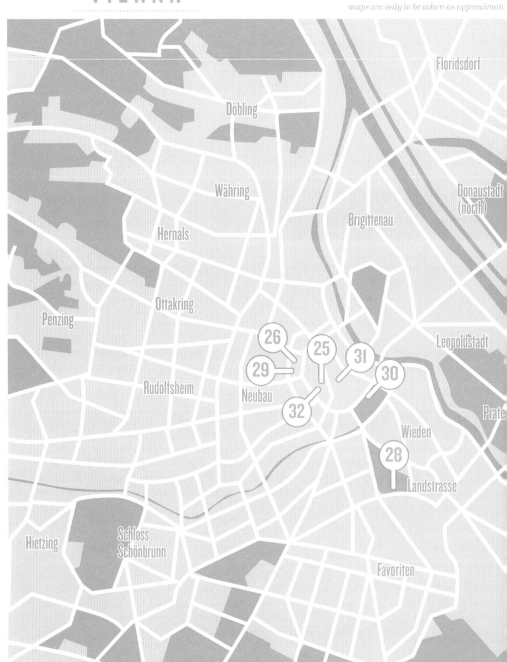

25.

THE SEVEN-PER-CENT SOLUTION (1976)
Prunksaal (Ceremonial Hall) of the Austrian
National Library, Josefsplatz 1, 1st District
page 72

26.

THE BOYS FROM BRAZIL (1978)
Interiors at historical central building of
the University of Vienna, Universitätsring 1
(as of 2012; formerly Dr Karl-Lueger-Ring 1),
1st District
page 74

27.

TALES FROM THE VIENNA WOODS/
GESCHICHTEN AUS DEM WIENERWALD (1979)
Stadlauer Ostbahnbrucke (Stadlauer Railroad
Bridge) over the Danube River and Isle
page 76

28.

BAD TIMING: A SENSUAL OBSESSION (1980)
The Austrian Gallery in the Belvedere Palace,
4th District
page 78

29.

BOCKERER/DER BOCKERER (1981)
Austrian Parliament,
Dr Karl-Renner-Ring 3, 1st District
page 80

30.

THE EXCLUDED/DIE AUSGESPERRTEN (1982)
Wien Fluss (Vienna River Canal),
Stadtpark (City Park), 1st District
page 82

31.

PEBBLES/KIESELSTEINE (1983)
Graben U1 subway entrance, 1st District
page 84

32.

'38 – VIENNA BEFORE THE FALL/
'38 – AUCH DAS WAR WIEN (1986)
Empress Elisabeth Memorial, Volksgarten
(People's Garden), Hofburg Palace, 1st District
page 86

THE SEVEN-PER-CENT SOLUTION (1976)

LOCATION *Prunksaal (Ceremonial Hall) of the Austrian National Library, Josefsplatz 1, 1st District*

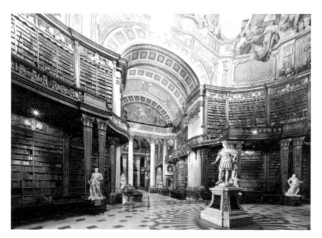

THE SEVEN-PER-CENT SOLUTION imagines a Sherlock Holmes (Nicol Williamson), circa 1891, mentally diminished by an addiction to cocaine and suffering from obsessive delusions about Professor Moriarty. Concerned, Watson (Robert Duvall) tricks him into travelling to Vienna, where he is expected by Sigmund Freud (Alan Arkin). Using hypnotism, Freud treats Holmes's addiction, and they join forces to thwart a desperate Austrian baron who has kidnapped a beautiful singer in order to use her to repay his gambling debts to a Turkish pasha. Sensing pursuit, the baron sends Lowenstein (Joel Grey), to distract his pursuers with a pointless chase. That chase leads to the former Court Library, today the Ceremonial Hall of the Austrian National Library. An extraordinary Viennese interior, its ceiling frescoes recall an era when allegorical figures, classical heroes and Greek mythology were the avatars of Austrian history, an era before the modern victory of rationality, realism and scientific inquiry, and its avatars Sherlock Holmes and Sigmund Freud. Completed in 1730 during the reign of Charles VI, the Ceremonial Room's cupola fresco places the goddess of eternal glory at its centre. In her right hand is the traditional obelisk; in her left, she holds both laurel wreath and palm branch. Under the leadership of Charles and the Habsburg dynasty, the fresco tells us, victory and peace are united. And taken together, the Room's paintings express a vision of the world in which the pre-eminent place of Habsburg Austria – given by God and secured by war – will forever endure. Meanwhile, few of the books owned by Freud remain in Vienna. Scattered across the world in Washington, DC, and in New York, the largest share of his library survives in London. **↝Michael Burri**

(Photos © Austrian National Library)

Directed by Herbert Ross
Scene description: Sherlock Holmes, Dr Watson and Sigmund Freud chase
Lowenstein in the Ceremonial Hall of the Austrian National Library
Timecode for scene: 1:05:23 – 1:06:42

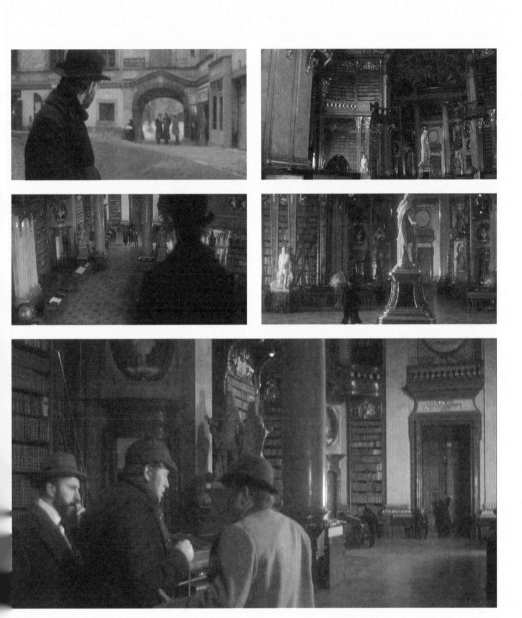

THE BOYS FROM BRAZIL (1978)

LOCATION *Interiors at historical central building of the University of Vienna, Universitätsring 1 (as of 2012; formerly Dr Karl-Lueger-Ring 1), 1st District*

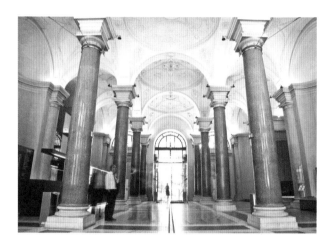

A PICARESQUE POLITICAL THRILLER, *The Boys from Brazil* moves from Paraguay to Germany and finally to a farmhouse in US Amish country, all in pursuit of a mysterious Nazi legacy. The fact that the film ends up in the American Midwest is truly a sardonic joke for our times. However, a large portion of the film is set in Vienna, headquarters of the fictional Nazi-hunter Ezra Lieberman (Laurence Olivier; modelled on the famous Simon Wiesenthal). Lieberman tries to stop a plot by former SS concentration camp physician Josef Mengele (Gregory Peck) to clone a new race of overachieving dictators from a sample of the Fuhrer's own DNA; hence the title. In fact, it is in consultation with genetic specialist Dr Bruckner (Bruno Ganz) in the neo-Renaissance university building on the historic Ringstrasse that Lieberman cracks the code about whose 'sons' these boys from Brazil really are. Lieberman and Dr Bruckner's meeting begins in the university's opulent boardrooms with inlaid wainscoting and grand hallways with alabaster columns; but when they move to a simple modern lab, faceless and antiseptic, the creepy embryo-vampiric horrors of cloning are fully revealed to the weary and disgusted Lieberman. Vienna, as it was in the imperial heyday of the Ringstrasse, remains in the vanguard of science, but for both good and ill. 'Wouldn't you want to live in a world of Mozarts and Picassos?' Dr Bruckner opines hopefully, but Lieberman soon corrects him: it is Hitler who is the subject of this cloning. Like the building Lieberman calls home – outside, a beautiful architectural specimen of the old city, but inside a cluttered labyrinth of groaning elevators, leaky ceilings and seedy, Kafkaesque landlords – the gorgeous baroque face of Vienna conceals a dystopian-futuristic soul. **➻Justin Vicari**

Scene description: A world of Mozarts or Hitlers?
A discussion about cloning with the expert
Timecode for scene: 1:24:13 – 1:33:34

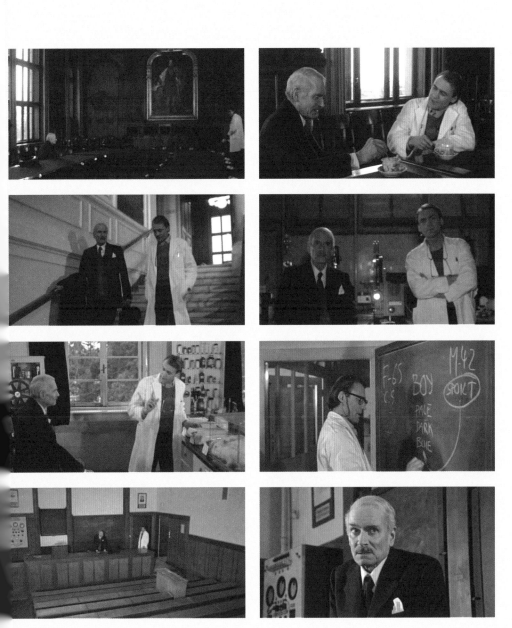

TALES FROM THE VIENNA WOODS/
GESCHICHTEN AUS DEM WIENERWALD (1979)

Stadlauer Ostbahnbrucke (Stadlauer Railroad Bridge) over the Danube River and Isle

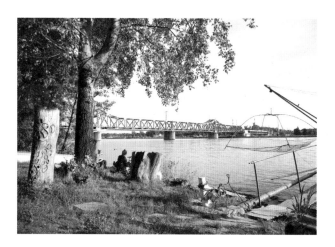

THE CAMERA TAKES US on a view to the Danube's left banks near the Stadlauer Bridge (opened 1870 as the longest Danube crossing in Vienna). In the early 1930s this area was prevalently used for little Sunday jaunts and picnics. The members of a typical petty bourgeois family, together with some friends, are celebrating two occurrences: on the one hand, the commemoration of a grandmother's death and, on the other, the engagement of Marianne with Oskar, a boorish butcher. The scene is brimming with people playing games, taking photos, reciting poems and singing songs. This seems to suggest openness, relaxation and sociability. But the double-edged manner in which Maximilian Schell places his characters in the shots also shows something else: most manners reveal themselves as perfidious social conventions. For example, Leopold, called the 'Magic King', a patriarchal grandfather and the supreme representative of the general morality, is secretly flirting with the tobacconist, a sprightly woman in her mid-fifties, who actually would prefer to have affairs with younger men. Nearby a German law student is practising gun firing exercises. Although uttered in this private sphere, his fascistic phrases already suggest the political developments to come. And then there is Marianne, the innocent 'sweet girl' type we find in many Viennese stage plays. Although she dares to reject her imposed engagement, the author Ödön von Horváth (1901–1938), whose works experienced a remarkable renaissance in the 1970s, portrays Marianne as a continued victim of male-dominated society. Without alternatives she becomes entangled in futile actions that carry her back into Oskar's arms. Stretched like a spider's web over the river, the transverse and longitudinal bracings of the Stadlauer Bridge slices away any clear view of the horizon – narrowing the scene and threatening it. **✦Arno Russegger**

Directed by Maximilian Schell

Scene description: 'You will not escape my love!' – The suffocation
of an average life in the everyday world of 1930s Vienna
Timecode for scene: 0:15:00 – 0:22:00

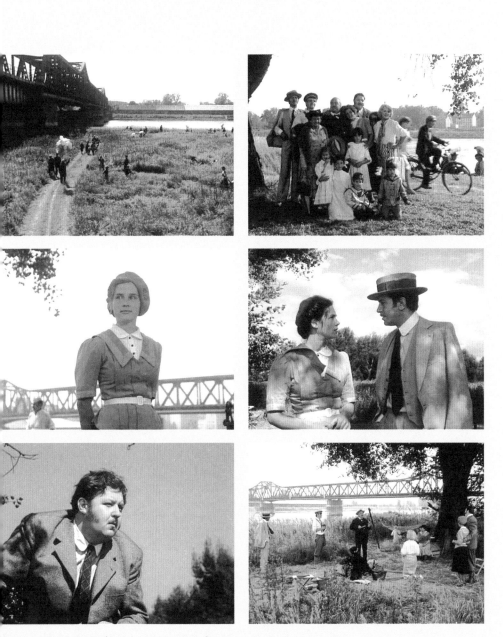

BAD TIMING: A SENSUAL OBSESSION (1980)

The Austrian Gallery in the Belvedere Palace, 4th District

'**TAKE ME TO YOUR FAVOURITE** place in Vienna,' messy, beautiful Milena (Theresa Russell) asks her doctor lover (Art Garfunkel) on their first date, and they go to the Klimt gallery inside the baroque Belvedere Palace, in the seventeenth-century home to the imperial Eugene of Savoy. But in *Bad Timing* it feels like a bourgeois, oddly domesticated space: Nicolas Roeg's camera alternates between plunging into close-ups of Klimt's ravishing patterns, or shooting the lovers from a distance as they prowl around these masterworks, and each other. They seem to be matching themselves to Klimt's erotic stars: The Kiss's caped man engulfing his kneeling mate on a cliff is perhaps the most famous artistic image that has come from Austria, and the painting's ambiguity (is this rescue or ravishment?) creates an overture for the remainder of the film. Milena is Klimtian woman, physically malleable, placed in extreme positions, ripe for male projection – although Roeg and Russell succeed in bringing to life a vulnerable, inarticulate young woman out of her depths and accidentally pushing too far, rather than a posed, ruthless sadomasochist. Like her synecdochic tongue, alternately kissing and convulsing in strangulation, Russell will be pursued, seduced, abandoned and all but killed by her obsessed lover in this spell they enter together, and which seems to have more to do with Vienna's erotic mystique than with them. Roeg's Vienna is poised midway between the dream of an imperial city and a nocturnal world of perverse degradation. Blowzy, mystified stand-ins for Klimt's prepossessing, otherworldly models, the lovers aspire to be free children in some playground, but that playground is not quite what it seems; so the sublime erotic spectacle which Klimt concocted from his hieratic eye and bold colour palette falls away into the depredations of a faded 'hook-up' culture. ➻*Justin Vicari*

Directed by Nicolas Roeg
Scene description: Contemporary Vienna as the city of
dangerous Eros: Klimt, seduction, and two unstable lovers
Timecode for scene: 0:00:00 – 0:02:01

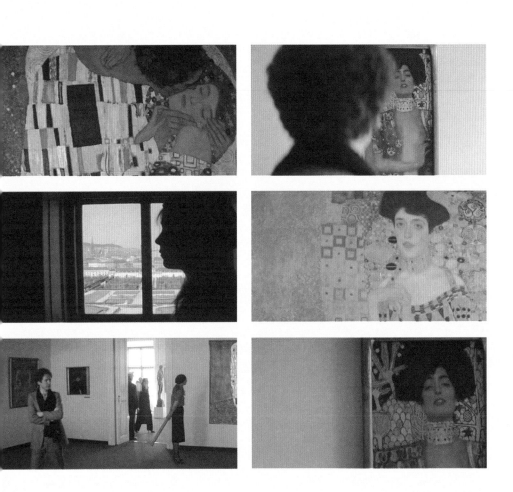

BOCKERER/DER BOCKERER (1981)

Austrian Parliament, Dr Karl-Renner-Ring 3, 1st District

BOCKERER opens with newsreel footage of German troops entering Austria in March of 1938 while Johann Gottfried Piefke's 1871 'The Glory of Prussia' military march is performed in the background. The scenes shift to Vienna's Heldenplatz, where Hitler addresses a large crowd of more than 100,000 spectators on 15 March. From the Hofburg Palace balcony where Hitler is addressing the crowd we see Vienna's City Hall and the white and gold neo-classical Parliament with its giant Pallas Athena statue, the monumental structures built during the *Gründerzeit* (founding period) between 1860 and 1890 along Vienna's Ringstrasse that replaced the city ramparts. Still in black-and-white, the scene shifts to the fictional film of a German soldier on a military truck in front of the Parliament building, waving and blowing kisses at the crowds on the boulevard. The film transitions into colour as a blonde young woman in a white shirt, most probably a member of the BDM (female section of the Hitler Youth), with flowers and a swastika flag in her hand comes up to the truck. She gives the soldier the flowers and a long kiss. The German soldier who was prepared for a fight to invade Austria is surprised by the welcome from these Viennese. This key scene in the film was groundbreaking in 1981, as the film ruptured the post-war myth of Austrians as pure victims of Nazi aggression. The Viennese characters in this entertainment-aimed film are clearly depicted as both victims and collaborators. **⇢Joseph W. Moser**

Directed by Franz Antel
Scene description: Coming to terms with the Nazi annexation in Austrian entertainment film
Timecode for scene: 0:01:20 – 0:01:51

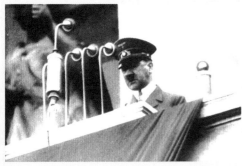 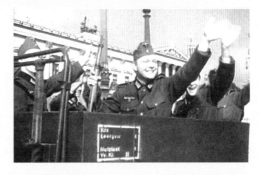

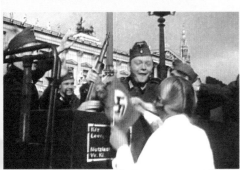 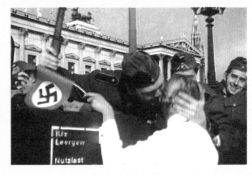

Images © 1981 Neue Delta/TIT Filmproduktion/Wien-Film

THE EXCLUDED/DIE AUSGESPERRTEN (1982)

Wien Fluss (Vienna River Canal), Stadtpark (City Park), 1st District

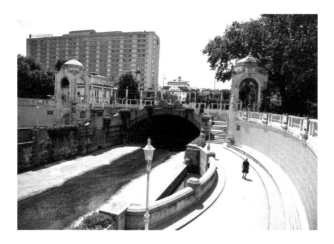

THE VIENNA RIVER near the Stadtpark participates in Vienna's redesigned *fin de siècle* splendour and in the subterranean canal system familiar from Reed's *The Third Man* (1949). Here, the showcase city and its underbelly meet. The year is 1959. High school student and gang leader Peter plans a test of courage for Sophie, whom he desires and wants to dominate. Representatives of different social strata are involved: the worker Hans, the lower-middle-class boy Peter and his twin sister Anna, and aristocratic heiress Sophie. Except for Hans, son of a murdered socialist, they are Nazi children, but the past is conveniently forgotten. Peter dreams of advancing from petty crime to terrorism to leave the squalor of his parental home behind. Anna compensates for her ineptness by reading Bataille and being promiscuous. Living in a dump of an apartment with their father, a former SS man turned pornographer and their servile mother, the twins have an affinity with the sewer sphere. The accomplished Sophie, in a light coloured fur coat, descends to the dirty rivulet merely for the sake of the experience. Peter, dressed in black, approaches her at river level, hands her a white Persian cat and orders her to drown it. She proceeds while he, aroused, watches. When Hans arrives on a stolen scooter he stops Sophie and ruins Peter's scheme. Defeated and bewildered, the twins linger arm in arm at the edge of the water until a policeman arrives. Hans sets the scooter on fire to secure their retreat. The setting above and below ground effectively frames the revelation that the society girl, who moves with ease on every level, is not only more accomplished but also more ruthless than her fellow would-be rebels. **↠Dagmar C. G. Lorenz**

Directed by Franz Novotny
Scene description: In a dysfunctional post-war Vienna,
the high school gang gives Sophie a gruesome test of courage
Timecode for scene: 0:45:02 – 0:46:45

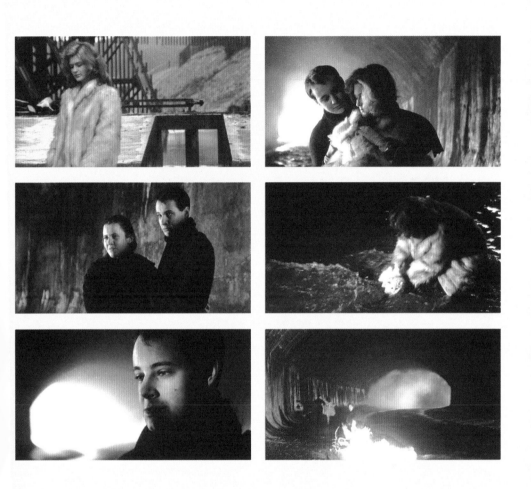

PEBBLES/KIESELSTEINE (1983)

LOCATION *Graben U1 subway entrance, 1st District*

THE FINAL SEGMENT of *Pebbles* begins in the heart of contemporary Vienna at the escalator of the U1 metro station Stephansplatz, exit Graben. This prominent pedestrian site for upscale shopping, people watching and socializing also marks the division between the elegant side of the First District and the parts descending towards the Danube Canal defined by Judenplatz, site of Vienna's first ghetto, the old Jewish Textile district, and Seitenstettengasse with the City Temple (Stadttempel), the only synagogue left standing in 1938. As the handrails and hardware of the subway escalator come in to view, Hannah Stern, dressed in red, walks at street level past the exit from which a dishevelled man in a raincoat ascends. He is familiar from a bar-room scene where he approached Hannah, supposedly to seek redemption for being a Nazi child and then cursing her when she recoils. He now lifts his hand in a respectful salute. Without taking notice she hurries toward an outdoor restaurant. Seated at a table is Hannah's date Friedrich, busily inspecting a Wagner recording he has just bought, an implied provocation to Hannah, the daughter of Holocaust survivors and painfully aware of the Nazi past. None of the iconic Christian edifices around the Graben – the Plague Column, St Stephan's Cathedral, St Peter's Church and Josefs-Fountain – are shown. The focus remains on the coffeehouse. Hannah, a modern woman, has repeatedly ignored the norms of her community without being accepted into gentile society. The Graben scene sets the tone for what is to come: Hannah's rape by a German Nazi's son and her departure into uncharted territory.
➙ Dagmar C. G. Lorenz

Directed by Lukas Stepanik
Scene description: The menacing ghosts of yesteryear cross
into contemporary Vienna and the life of Hannah Stern
Timecode for scene: 1:28:21 – 1:28:30

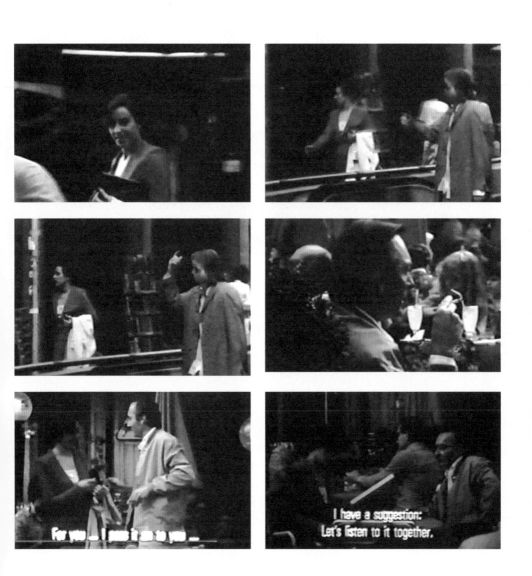

'38 – VIENNA BEFORE THE FALL/
'38 – AUCH DAS WAR WIEN (1986)

Empress Elisabeth Memorial, Volksgarten (People's Garden), Hofburg Palace, 1st District

HOW CAN ONE RECONCILE the Vienna of a glorious empire and rich cultural life with the city where in 1938 hundreds of thousands of Austrians welcomed Hitler? The love story between the Jewish journalist Martin and the non-Jewish actress Carola is set in a Vienna of contradictions, portrayed through nostalgic images, which contrast sharply with signs of a growing nationalism and Nazi presence. In the end the couple must separate. When the pregnant Carola flees to Prague, Martin attempts to follow her but is picked up by the Gestapo. One early scene, where the lovers argue about whether their relationship has any future, foreshadows the imminent changes in Vienna as it is integrated into the Third Reich. Carola announces 'I don't bother about politics,' to which Martin responds 'Hopefully politics will not bother about you one day.' But such ominous allusions seem out of place among the lush rose gardens and reflecting pools of the Volksgarten, where the couple walks. This was the first imperial park dedicated to the common people, and it is overseen by a statue of Empress Elisabeth. Nicknamed 'Sissi', the empress's image is that of a people's princess, a rebel against the authoritarian regimentation of imperial life, who was beloved by and benevolent to the many peoples of her empire. There is a poignant moment as Martin and Carola exit the scene. The camera pans from this couple, whose relationship is doomed, to linger on the Sissi statue, which has become mythologized as an icon of Vienna's pre-fascist, heterogeneous population and non-authoritarian legacy. **⇢Mary Wauchope**

Directed by Wolfgang Glück

Scene description: Time runs out for two lovers as Nazism threatens

Timecode for scene: 0:07:06 – 0:10:37

WONDER WHEEL

Text by
TODD
HERZOG

The Cinematic Prater

THE PRATER HAS HAD a close relationship with film since the earliest days of the medium. It was the site of some of Austria's first film recordings and screenings and its possible first feature-length film (*Von Stufe zu Stufe/Step by Step* [Heinz Hanus, 1908]; considered unfinished or lost). By the early twentieth century it was Vienna's central movie district. The early 'cinema of attractions' was naturally drawn to the Prater, depicting its performers, the parades down its tree-lined boulevards, and its grand exhibitions.

These early actualities established the aesthetic that dominates cinematic representations of the Prater to this day. A Prater scene is almost always a montage sequence featuring a series of requisite shots: an extreme high-angle view from the Riesenrad (the giant Ferris wheel erected in 1897 to celebrate Emperor Franz Joseph's Golden Jubilee; one of the first of its kind and the longest survivor), a close-up of balloons for sale, a leisurely ride through the park, and most significantly a liberated camera that takes a first-person perspective on an amusement

ride. Add some dancing, music, and eventually the animatronic gorilla and you have the aesthetic ingredients for nearly every cinematic appearance the Prater has made.

All of these elements are present in *Die Pratermizzi/Mizzi of the Prater* (Gustav Ucicky, 1926), which took up the long tradition of the Prater as a space where differences in class and ethnicity – otherwise so important in Vienna – could be temporarily suspended. A baron (Igo Sym) falls in love with a Prater cashier (Anny Ondra), but is tempted by a mysterious masked woman (Nita Naldi). When the mask is lifted to reveal a disfigured face, the baron contemplates suicide and Mizzi uncannily emerges from a display of wax figures to save him. Mizzi of the Prater establishes nearly all of the tropes that would be repeated in countless films to follow: the Prater as a romantic space where unlikely couples fall in love, a mysterious and treacherous space hidden behind an enticing mask, and an uncanny space where people and attractions stand in an uncertain relationship with one another.

The romantic Prater appears in *Letter from an Unknown Woman* (Max Ophüls, 1948), a heartbreaking tale of unfulfilled dreams. Lisa (Joan Fontaine) and Stefan (Louis Jordan) meet and spend a romantic evening in the Prater strolling, dancing, and riding amusements. Vienna's Prater was recreated on a Universal Studios stage in California, but it remains one of the most unforgettable appearances of the Prater in cinema history. Max Ophüls films the Prater in a way that depicts Lisa's romantic imagination, but also reveals the reality behind the illusion: the man who peddles the panoramic train ride the couple takes; the musicians who complain about dancers such as Lisa and Stefan who keep them up late. Almost fifty years later, another couple would repeat Lisa and Stefan's romantic night in Vienna

in Richard Linklater's *Before Sunrise* (1995). Jessie (Ethan Hawke) and Celine (Julie Delpy) share their first kiss on the Riesenrad before walking and talking through the Prater. They discuss whether all generations share the same fundamental experiences while they enact a scene of brief romance in the Prater that has played out similarly across many generations of cinematic lovers.

Kurt Steinwendner's episodic, neo-realist film (one of the very few from Austria in the 1950s) *Wienerinnen/Vienna Women* (1952) shares little stylistically with Ophüls's and Linklater's films, but it too depicts the Prater as a space of brief, intense and unlikely romance. In one episode, Olga (Margit Herzog), a prostitute, meets Carlo (Rudolf Rhomberg), a ship's captain. They spend a joyous afternoon in the Prater, bicycling through the park, laughing on the merry-go-round, screaming in the haunted house – but are secretly pursued and ultimately confronted by Olga's pimp, Anton (Kurt Jaggberg). Danger also lurks behind romance in *The Living Daylights* (John Glen, 1987): James Bond (Timothy Dalton) is scheduled to meet a contact in the Prater Café. He eventually does meet his contact, who is pursued and ultimately killed by an assassin masquerading as a balloon salesman, but only after seducing his adversary's girlfriend (Maryam d'Abo) atop

the Riesenrad.

There is nothing romantic about the reunion of Holly (Joseph Cotten) and Harry (Orson Welles) in *The Third Man* (Carol Reed, 1949). In one of the most iconic scenes in film history, Harry Lime conveys his cynical world view to his former friend while the two ride on the Riesenrad, where, from Harry's perspective, the visitors below are not people, but 'dots', and the productive bloodshed of Italy under the Borgias is preferable to the unproductive peacefulness of Switzerland. Society's most marginal figures – criminals, gamblers, imposters, struggling artists – have populated the Prater in films such as *Merry-Go-Round* (Rupert Julian/Erich von Stroheim, 1923), *Vorstadtvarieté/Suburban Cabaret* (Werner Hochbaum, 1935) and *Prater* (Willy Schmidt-Gentner, 1936). These characters dream of a bourgeois existence that continually eludes them and the Prater is depicted both as a space outside mainstream society and a mirror of that society. This is especially clear in Franz Novotny's cult film *Exit... nur keine Panik/ Exit... But Don't Panic* (1980) in which the Prater – stripped of genuine romance and intrigue – offers instead vulgar sexuality and petty crimes that substitute for unattainable desires.

The uncanny has always been at home in the Prater. In Mara Mattuschka's experimental short *Plasma* (2004), *Mimi Minus* (Mattuschka) enters a hall of mirrors, initially playing with, but ultimately becoming conflated with her distorted reflection. As the distorted Mimi flees the hall, an advertisement promises 'Fun for Everybody'. Here the Prater's playfully uncanny amusements have overstepped the boundaries of fantasy and invaded the 'real world' – becoming more frightening than fun. The Prater is both uncanny and fun as the star of Ulrike Ottinger's *Prater* (2007). Incorporating footage from earlier films, this documentary passes through time and space without ever leaving the Prater to reveal the connections and tensions between people and machines, sounds and images, and Ottinger's camera and the Prater's amusements. The Prater itself has always been a cinematic experience. Like cinema, it is a dream-machine, a desire-machine, a memory-machine, and a time-machine. Like cinema, it is a space of romance, danger, and the uncanny that can thrill, seduce and frighten its spectators – usually all at once. ✚

The early 'cinema of attractions' was naturally drawn to the Prater, depicting its performers, the parades down its tree-lined boulevards, and its grand exhibitions.

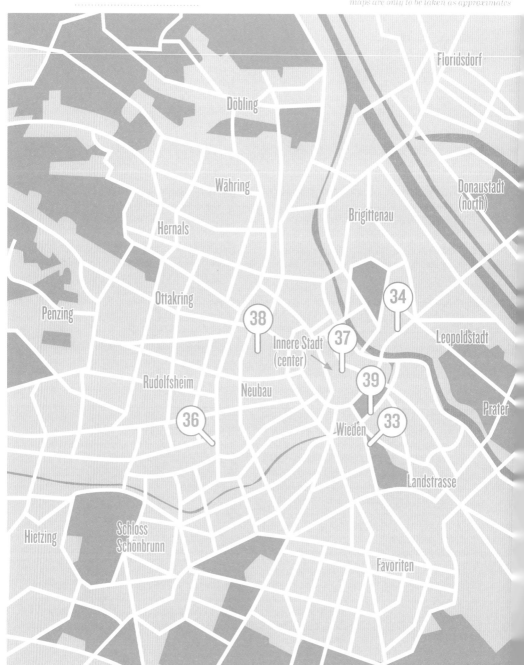

Floridsdorf

Döbling

Währing

Brigittenau

Donaustadt
(north)

Hernals

Ottakring

34

Penzing

38

Leopoldstadt

Innere Stadt
(center)

37

Rudolfsheim

Neubau

39

Prater

36

Wieden

33

Landstrasse

Hietzing

Schloss
Schönbrunn

Favoriten

VIENNA LOCATIONS
SCENES 33-39

Donaustadt
(south)

mmering

35

33.
THE LIVING DAYLIGHTS (1987)
Hotel im Palais Schwarzenberg,
Schwarzenbergplatz, 3rd District
page 92

34.
I LOVE VIENNA (1991)
Hotel Praterstern, Mayergasse 6,
2nd District
page 94

35.
IMMORTAL BELOVED (1994)
Zentralfriedhof (Central Cemetery),
11th District
page 96

36.
BEFORE SUNRISE (1995)
Westbahnhof (Western Train Station),
Europaplatz 2, 15th District
page 98

37.
NORTHERN SKIRTS/NORDRAND (1999)
Stephansplatz (St Stephan's Cathedral
Square), 1st District
page 100

38.
BORN IN ABSURDISTAN/
GEBOREN IN ABSURDISTAN (1999)
Standesamt, Schlesingerplatz 4,
8th District
page 102

39.
THE PIANO TEACHER/LA PIANISTE (2001)
Wiener Konzerthaus (Vienna Concert
House), Lothringerstrasse 20, 3rd District
page 104

THE LIVING DAYLIGHTS (1987)

LOCATION *Hotel im Palais Schwarzenberg, Schwarzenbergplatz, 3rd District*

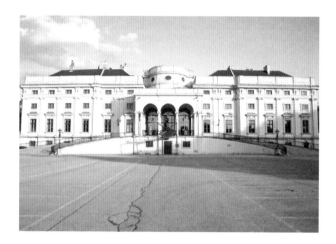

THE LIVING DAYLIGHTS marks the end of the grand international Cold War thriller set in Vienna. Such films generated much excitement, and the city fully accommodated the Bond production team. Then Vienna Mayor Helmut Zilk is reputed to have said that they could even blow up the Vienna subway. It survived, but in a characteristically Viennese turn of events, Zilk has now purportedly been linked to Czech and possibly US intelligence. James Bond (Timothy Dalton) arrives in Vienna via a fresh produce delivery truck, accompanied by the beautiful cellist Kara Milovy (Maryam d'Abo), whom he has just spirited across the border from Bratislava. The city they encounter is Vienna storybook and Hollywood storyboard. With the romantic couple riding in a horse-drawn carriage, the film checks the traditional best-of-Vienna locations – the Prater, Schönbrunn Palace, Museumsplatz. And as a Strauss waltz playing in the background suggests, the landmarks themselves are separated only by a few beats in 3/4 time. Turning the corner from Schönbrunn, their carriage arrives magically at the Hotel at the Schwarzenberg Palace across the city. James Bond was not the first quasi-rock star to be filmed crashing this princely site. Falco, the 1980s Austrian pop music icon shot his 'Rock Me, Amadeus' video on the premises. *The Living Daylights* actually quotes Falco's entrance, via horse-drawn carriage. Milovy wanders into the boutique and falls in love with western designer clothing. Naturally, Bond buys. Is it a defensive gesture? Perhaps. After all, it might be said that the east begins at the Schwarzenberg Palace (1697–1728). Its northern end directly faces the Soviet War Memorial and from 1946 to 1956 the area beyond the Memorial was known as Stalinplatz (Stalin Square). •➤ **Michael Burri**

Scene description: *Vienna check-in: James Bond arrives at*
the 'Hotel in the Schwarzenberg Palace' with Kara Milovy
Timecode for scene: *0:55:58 – 0:57:06*

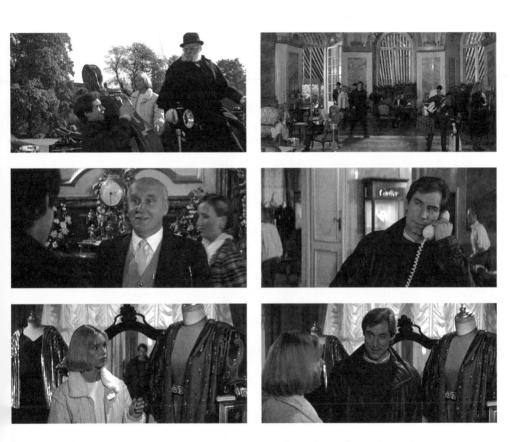

I LOVE VIENNA (1991)

LOCATION *Hotel Praterstern, Mayergasse 6, 2nd District*

AT THE BEGINNING OF *I Love Vienna*, the strict Iranian patriarch Ali Mohammed (Fereydoun Farokhzad), a German teacher whose romantic view of Vienna has been moulded by the 1950s *Sissi* films, his sister Marjam (Marjam Allahyari) and 15-year-old son Kurosh (Kurosh Allahyari) arrive at Vienna's noisy, grimy Südbahnhof and are brought by Ali's nephew to the accommodation that has been arranged for them: a simple hotel across from a brothel in Vienna's Second District, around the corner from the huge Ferris wheel landmark, the Riesenrad. The three find themselves in a city very different from their exalted expectations, confronted by sexual temptation at every turn. The tables are ironically turned, however, when Marjam falls in love with and decides to marry a Polish asylum-seeker friend of Ali's nephew willing to convert to Islam for her. Cultural differences are negotiated and accommodated in a city whose quirky inhabitants defy the cultural stereotypes projected by well-known sites such as the Prater and Schönbrunn Palace and leave hopeful newcomers confined to claustrophobic and rigidly controlled spaces that stand in stark contrast to the baroque expanses of the city's architectural heritage. The film's contrasting locations thus both confirm and challenge Vienna's urban imaginary at a time when the city was about to change irrevocably during the waves of migration immediately before and after the fall of the Iron Curtain.
•◦ Susan Ingram and Markus Reisenleitner

Directed by Houchang Allahyari
Scene description: A family from Iran checks into an unknown Vienna
Timecode for scene: 0:00:00 – 0:12:18

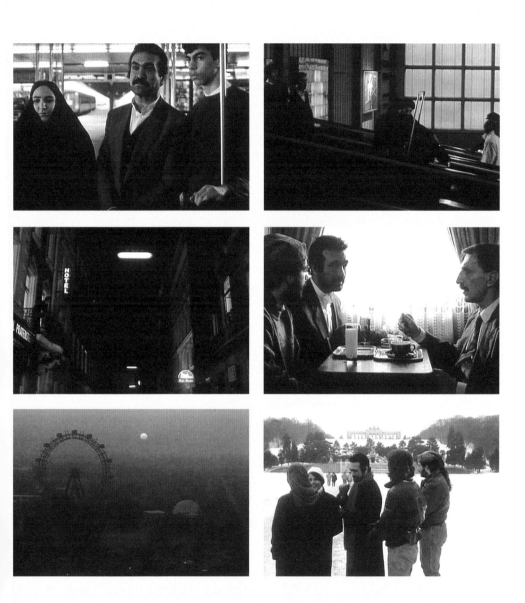

IMMORTAL BELOVED (1992)

LOCATION *Zentralfriedhof (Central Cemetery), 11th District*

IN THE FINAL SCENE of the film, Ludwig van Beethoven's supposed great love visits his gravesite after discovering that his abandonment of her and their unborn child years before was due to a missed rendezvous and an unread missive. The narrative's fiction is suggested by an 1812 letter written to an unnamed 'Immortal Beloved' found among the late composer's papers. The affecting conclusion shot at Beethoven's current cemetery but with cinematically altered setting and tomb, underscores the fact that nearly all biopics on the great composers connected with Vienna (*Wen die Götter lieben/ Whom the Gods Love; Eroica; Amadeus,* etc.) have been made in a studio or at substitute locations. Even here, German locales stand in for Beethoven's adopted home of Vienna and filmic fantasy triumphs in the ending. Unlike Mozart, who was buried in an unmarked mass grave outside the city walls at the St Marx Cemetery (now in the 3rd District), Beethoven's funeral on 29 March 1827 was attended by approximately 20,000 mourners including Austrian composer Franz Schubert and playwright Franz Grillparzer, and he was buried in a eminent location north-west of the city. His remains were exhumed for study in 1862 and not actually interred at Vienna's Zentralfriedhof until 1888. The Central Cemetery, opened in 1874 to provide for the expansion of the city, is one of the largest in the world. Beyond its important appearance in *The Third Man* (Carol Reed, 1949), it is renowned for a monumental *Jugendstil* church, graves of honour, vast memorial sites for war dead, and a unique multi-denominational design. **◆ Robert Dassanowsky**

Directed by Bernard Rose
Scene description: At Beethoven's grave
Timecode for scene: 1:56:22 – 1:57:00

BEFORE SUNRISE (1995)

LOCATION *Westbahnhof (Western Train Station), Europaplatz 2, 15th District*

IN THE FINAL SCENE of *Before Sunrise*, a prototypically postmodern romance starring Ethan Hawke and Julie Delpy, the twenty-something American male and French female who have met on a train along the route of the Orient Express and spontaneously decided to disembark and spend a day and night together in a fairy tale Vienna must take leave of each other. The strings of a Bach sonata start up, and the camera returns us to some of the quintessentially Viennese spots the two have enjoyed during their romantic stopover, places which are now awakening to the morning sun. Although everyday life has gone on, and the symbolism in the scene of public transport, garbage trucks, and the odd passersby ambling along tells us it will continue to do so, we also understand that these places are not as empty as they appear. Rather, they have been enchanted for the two, and by extension for the global movie-going public, with memories of the shared glances, kisses and caresses to which Vienna has been a complicit witness. No less important are the quirky creatures the pair encounter during their nocturnal peregrinations in this charmed and charming city over which time does not seem to have any power.
•❧ Susan Ingram and Markus Reisenleitner

Directed by Richard Linklater
Scene description: *A couple separate from their own
brief enchantment in Vienna: 'Au Revoir... Later.'*
Timecode for scene: *1:32:31 - 1:37:53*

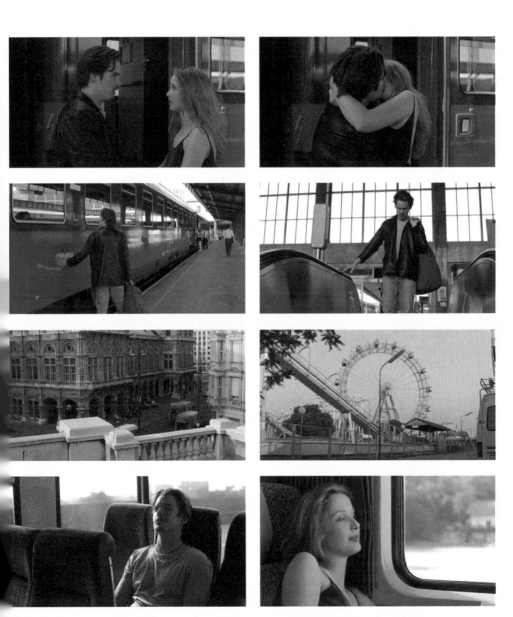

NORTHERN SKIRTS/NORDRAND (1999)

LOCATION *Stephansplatz (St Stephan's Cathedral Square), 1st District*

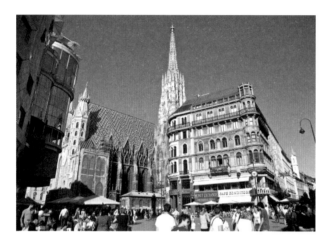

THE EXUBERANT NEW YEAR'S celebration on St Stephan's Square amidst fireworks, traditional Viennese waltz music, hugs, kisses and champagne encapsulates the dynamic of *Northern Skirts*. The public ecstasy unites Austrians, 'foreigners', and members of warring cultures including the four protagonists, but it lasts only for a brief moment. Set amidst a site that reveals the passing of time – the immense gothic cathedral, the postmodern glass-and-steel 'Haashaus', the traditional venue of the Aida Café, Jasmin's workplace and an international meeting spot come into view – the revelry elicits an elusive harmony that ends when the music stops and cleanup crews arrive to sweep away the waste. Equally transitory are the moments of intimacy in this film, which is about a fragmented society impacted by the military conflicts in neighbouring countries. Throughout, Albert points to the effects of extremism, xenophobia, and the abuse of women in a wealthy country that is also known for its generous public services. Once the two female protagonists, Jasmin of Austrian and Tamara of Serbian background, experience genuine affection in their short-term relationships with Eastern European migrants, the Bosnian Senad and the Rumanian Valentin, return to their Austrian lovers, or for Jasmine, to her father, is out of the question. As the women exchange their dance partners in the cathedral square, the New Year's Eve celebration becomes a celebration of sisterhood. Rather than advocating the restoration of the nuclear family, the film validates transformative epiphanies among men and women that like the magic hour in the heart of Vienna will not endure. However, the two women's solidarity points towards emerging new social patterns. ↪ *Dagmar C. G. Lorenz*

Directed by Barbara Albert
Scene description: After a few moments of
sentimental joy, a sober possibility for the real future
Timecode for scene: 0:24:35 – 0:29:17

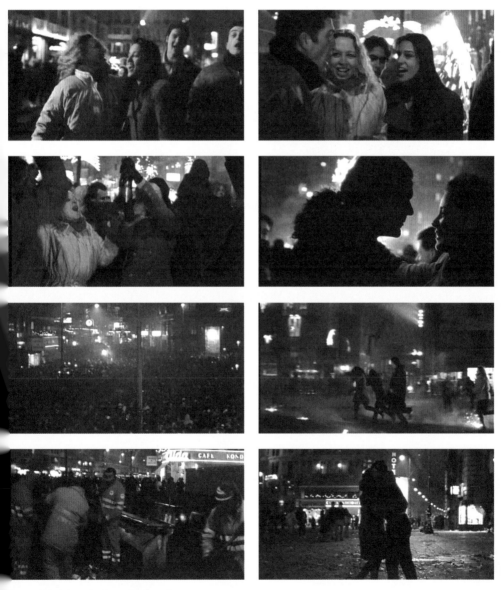

BORN IN ABSURDISTAN/
GEBOREN IN ABSURDISTAN (1999)

LOCATION *Standesamt, Schlesingerplatz 4, 8th District*

MUNDANE OFFICES OF civil servants are central to Allahyari's comedy, in which an Austrian bureaucrat and a Turkish migrant suspect that their newborn sons have been switched at birth. When the Dönmez family approaches the district city hall hoping to obtain a birth certificate, it is the barking dog, not the splendid *Jugendstil* façade that signals the bureaucratic welcome awaiting them. The Dönmezs' Turkish documents do not meet Austrian specifications, and the couple heads from office to office in a Kafkaesque undertaking, only to learn they are still not in the right place. After missing a registration deadline, the Dönmez couple is deported just before the Austrian Strohmeyer family learns about the possible mix-up. Accustomed to determining the fates of migrants' applications, immigration officer Stefan Strohmeyer now experiences his own dislocation when he and his wife head to Turkey to find the Dönmez family and attempt to smuggle them into Austria. Increased migration to Austria after the fall of the Iron Curtain prompted stricter immigration and asylum legislation, widespread debate about foreigners, and even a xenophobic series of letter bombs. In the year *Absurdistan* was released, the extreme right Freedom Party railed against Austria's alleged 'over-foreign-ization' and loss of identity. That anxiety is radically, if lightheartedly, dispelled in the film's utopian conclusion, as the two families, standing before another imposing office building, resolve to rear their children together, in spite of the hostile reception they know to be inside.
•❖ Nikhil Sathe

Directed by Houchang Allahyari

Scene description: A climactic scene at a majestic
district city hall which resolves... nothing
Timecode for scene: 0:18:23 – 0:20:49

 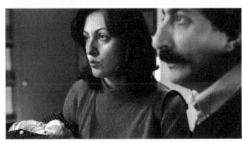

THE PIANO TEACHER/
LA PIANISTE (2001)

LOCATION *Wiener Konzerthaus (Vienna Concert House),*
Lothringerstrasse 20, 3rd District

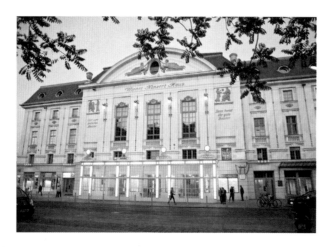

BASED ON THE NOVEL by Nobel Prize winning Austrian writer Elfriede
Jelinek, the life of the piano teacher in Michael Haneke's eponymous film
seems to fall into the extremes of the public/private divide: here the well-
respected teacher at a conservatory, there a deeply troubled woman who cuts
herself and seeks relief as a sexual voyeur. For the repressed Erika Kohut
(Isabelle Huppert), the Konzerthaus represents the site of her failures. Not good
enough to become a concert pianist herself, she is now condemned to observe
her students perform. The two sequences set in the Vienna Konzerthaus
(built 1913) show nothing of the recently renovated building, but concentrate
instead on two in-between spaces, the toilet and the wardrobe. Belonging to
the building, but having nothing to do with its purpose as an iconic venue for
musical performances, these two off-sites become a stage for an enactment
of Erika Kohut's desires. Indeed, in Michael Haneke's Austrian German, the
toilet is known as the 'Abort', literally the off site, the 'ob-scene'. And the semi-
public wardrobe is re-territorialized as an ob-scene site of mutilation. First,
Kohut ends the career of one of her female students (who might be seen as
her doppelgänger) by slipping shards of glass into the girl's coat pocket after a
rehearsal. Then, following the difficult and finally violent sexual encounters
with her prize student and object of desire Walter Klemmer (Benoît Magimel),
she plans a public confrontation during his performance at the Konzerthaus.
Standing in front of the building, Kohut turns inward once again, stabbing
herself in the chest with a kitchen knife meant for Klemmer and disappearing
out of the frame. **→Oliver C. Speck**

Scene description: A pianist hides her dark other side in the 'off sites' of the Vienna Konzerthaus
Timecode for scene: 0:53:13 – 1:14:05

THE SPACES OF THE OTHER VIENNA IN NEW AUSTRIAN FILM

Text by NIKHIL SATHE

ALTHOUGH POPULAR MEMORY canonizes the fall of the Berlin Wall in November 1989, the Iron Curtain indeed first opened that summer on the Austrian-Hungarian border, initiating a volatile period of realignment for Austria, including entry into the EU and, until that organization's eastward expansion, a role as outer rampart of 'Fortress Europe'. Anxiety about this barrier existed long beforehand, as Austria experienced increased traffic from Eastern Europe and the Global South, and especially from refugees and migrants from the former Yugoslavia. The Austrian Freedom Party (FPÖ) exploited voter anxieties about foreigners and shaped national politics, as coalition parties co-opted their positions, passing some of Europe's most restrictive immigration laws.

These contexts provide the backdrop and catalyst in which Austrian cinema since the 1990s has flourished. This cinema, whose stories and institutions centre on Vienna, is characterized by a predilection for society's underbelly, strong formal agendas, and an unflinching realism that interrogates Austria's shifting self-definitions. For established and younger film-makers, a central focus remains

the problematic of foreign 'others', especially Eastern Europeans.

Surely the key locale is the border, a space from which film-makers examine how the centre seeks to determine and control who belongs inside. To be sure, Vienna is not on the border, but many films foreground how, for migrants, the policing of the border remains omnipresent. The title of Barbara Albert's *Nordrand/Northern Skirts* (1999) refers to Vienna's northern districts, but the film's characters face border controls everywhere: an illegal Romanian migrant sneaks past an identification check and a Bosnian fleeing military service easily slips across the Austrian border, only to escape narrowly a raid at a day labourer market. For the Georgian protagonist in Florian Flicker's *Suzie Washington* (1998), a forged passport imprisons her to the Vienna airport's transit area until her deportation, but after managing to escape, she becomes the target of a nationwide search. A real manhunt is the focus of the documentary *Operation Spring* by Angelika Schuster and Tristan Sindelgruber (2005), which dissects the Viennese police's controversial drug raid directed at dark-skinned migrants. Especially since the 2004 EU expansion, Austrian cinema has shifted its emphasis from the patrolling of the border to its porousness. In Andreas Gruber's *Welcome Home* (2004), a policeman becomes unwilling to deport a Ghanaian and allows his newfound friend to exit the Vienna airport illegally. Erwin Wagenhofer's *Black Brown White* (2011) opens at a trucking office in Vienna, where the upcoming delivery is later revealed to entail the illegal transport of Africans into the EU.

If this cinema increasingly places less emphasis on the actual border, it continues to highlight invisible societal boundaries for its 'others'. In numerous films, economic and legal categories enforce the migrant's

Opposite © 2005 Icon Film, Amour Fou Filmproduktion
Above © 2002 Bonus Film

marginalization. Ulrich Seidl's early documentary *Good News* (1990) details the harsh work and living conditions of mostly South Asian newspaper vendors, and his feature film *Import/Export* (2007) follows its protagonist, a trained nurse in the Ukraine, along the series of menial jobs that her status in Vienna allows. After her border transgression, the Polish protagonist in Ruth Mader's *Struggle* (2003) has even less status in Vienna, where the day labourer market offers her only temporary, laborious jobs cleaning, packing and eventually performing as a sex worker. In many films illicit milieus, in particular prostitution, appear as the only avenue for migrants to establish a footing. Michael Sturminger's *Hurensohn/The Whore's Son* (2004) depicts a Croatian's coming of age in Vienna while war rages in his family's homeland and he struggles with his mother's profession. In Barbara Gräftner's *Mein Russland/My Russia* (2002), a Ukrainian cannot escape her past as a stripper when her meddling mother-in-law leverages it against her to manipulate her son.

Aside from their workplace, migrants in Austrian cinema predominantly appear in generic public spaces: shopping malls, subways, train stations and public parks or squares. These transient spaces foreground the impermanence and fragility of the

migrant's status. In Jörg Kalt's *Crash Test Dummies* (2005), the Romanian protagonist can only find a temporary connection with a Viennese security guard, by standing in front of the mall surveillance camera he monitors and where she first encountered him. When iconic Viennese spaces do appear in this cinema, they are often depicted ironically or subversively. *Crash Test Dummies* highlights the incongruity of a Romanian's fling with a Viennese woman by staging their breakfast at a chic cafe overlooking St Stephan's Cathedral. This site also appears in *Northern Skirts*, where the multilingual cast counts down the New Year and waltzes to the Blue Danube, overwriting the locale's national significance.

Less prevalent than in other European cinemas are Viennese stories exclusively connected to migrants and foreigners. Some notable exceptions include Goran Rebic's *Jugofilm/Yugo-Film* (1997), which addresses the Balkan wars through a family of Serbian immigrants in Vienna. In both the feature *Nachtreise/Night Journey* (1994), set in a cafe frequented by Turkish men, and the documentary *Gurbet – In der Fremde/Away From Home* (2007) Kenan Kiliç examines the lives of Turkish immigrants in Vienna. Another principal transcultural film-maker is Iranian-born Houchang Allahyari. His *I Love Vienna* (1991) centres on an immigrant's arrival in Vienna and his comedy *Geboren in Absurdistan/Born in Absurdistan* (1999) satirizes the impossibility of identity. More recently, Allahyari's documentaries, *Bock for President* (2010) and *Die verrückte Welt der Ute Bock/The Crazy World of Ute Bock* (2010), portray the renowned Viennese activist for refugees and asylum seekers.

The spaces of foreigner others emerging in Austrian cinema since the 1990s reveal a Vienna far removed from the romantic fantasies of imperial Vienna and darker, more intense than in earlier stories anchored in specific districts or working-class areas. Constantly aware of the border's pervasive authority, migrants in this cinema inhabit transient spaces, and the natives' secure certainty of identity is unsettled by the subversive depiction of prominent Viennese spaces. While Europe's peripheral borders may be falling, for migrants, this cinematic Vienna indicates their place within them remains in flux. ✤

Aside from their workplace, migrants in Austrian cinema predominantly appear in generic public spaces: shopping malls, subways, train stations and public parks or squares. These transient spaces foreground the impermanence and fragility of the migrant's status.

VIENNA

maps are only to be taken as approximates

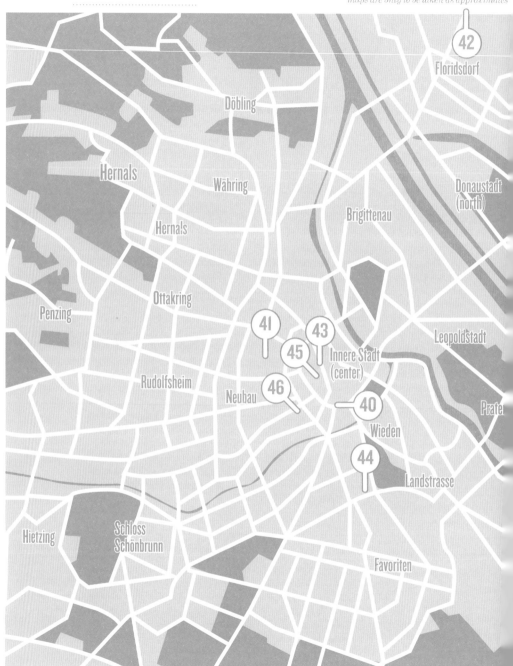

N

42
Floridsdorf

Döbling

Hernals

Währing

Donaustädt
(north)

Brigittenau

Hernals

Leopoldstadt

Ottakring

Penzing

41

43

45

Innere Stadt
(center)

Prater

Rudolfsheim

46

Neubau

40

Wieden

44

Landstrasse

Hietzing

Schloss
Schönbrunn

Favoriten

VIENNA LOCATIONS
SCENES 40-46

Donaustadt
(south)

ımering

40.
BRIDE OF THE WIND (2001)
Vienna State Opera House,
Opernring 2 (Opera-Ring), 1st District
page 110

41.
GEBIRTIG/GEBÜRTIG (2002)
Florianigasse 43, 8th District
page 112

42.
ANTARES (2004)
Jedlersdorfer Strasse 99, 21st District
page 114

43.
KLIMT (2006)
Café Central, Palais Ferstel,
Herrengasse 14, 1st District
page 116

44.
IMPORT/EXPORT (2007)
Former Südbahnhof (Southern Train
Station), Wiedner Gürtel 1, 4th District
page 118

45.
THE ROBBER/DER RÄUBER (2010)
Heldenplatz, Hofburg Palace, 1st District
page 120

46.
A DANGEROUS METHOD (2011)
Café Sperl, Gumpendorfer Strasse 11,
6th District
page 122

BRIDE OF THE WIND (2001)

Vienna State Opera House, Opernring 2 (Opera-Ring), 1st District

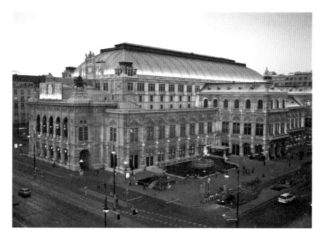
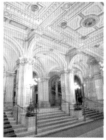

THE STORY OF THE Viennese beauty and composer Alma Schindler, a legendary muse to some of the greatest artists in the German-speaking world during the early twentieth century provides an interesting platform for examination of the difficult emancipation of women from artistic object to artist, and the complex lives of men who brought the modern arts to early greatness. The film follows Alma's (Sarah Wynter) tumultuous marriages to Austrian composer and conductor Gustav Mahler, German Bauhaus architect Walter Gropius, and Viennese author Franz Werfel, as well as her relationships with Austrian painters Oskar Kokoschka (the title of the film refers to his 1914 expressionist painting of Alma also known as 'The Tempest'), Gustav Klimt and musician Alexander von Zemlinsky. Beresford's vivid visual and aural richness of late imperial Vienna as hothouse of creative expression overwhelms an uneven narrative of seduction, angst, egoism, domineering mothers, class conflict and war, but it is reasonable that it does so, since it was the heady, unstable mix of transcultural possibilities that ultimately overwhelmed the polyglot Austro-Hungarian monarchy itself. Mahler's (Jonathan Pryce) invitation to an outspokenly critical Alma to appreciate his new music during a rehearsal as conductor of the Vienna Philharmonic in the Opera House (completed 1869; partially destroyed by American bombardment 1945; reopened following extensive reconstruction in 1955) and their intellectual flirtation as they descend the marble neo-Renaissance grand staircase, is just one of the many set pieces of the film that manages to re-mythologize its subjects and deliver a Vienna that seems to be a borrowed setting from some immense tragicomic opera. ➜**Robert Dassanowsky**

Directed by Bruce Beresford
Scene description: Composer/conductor Gustav Mahler is
fascinated by the opinionated beauty (and future wife) Alma
Schindler on the grand staircase of the Opera House
Timecode for scene: 0:12:29 – 0:13:39

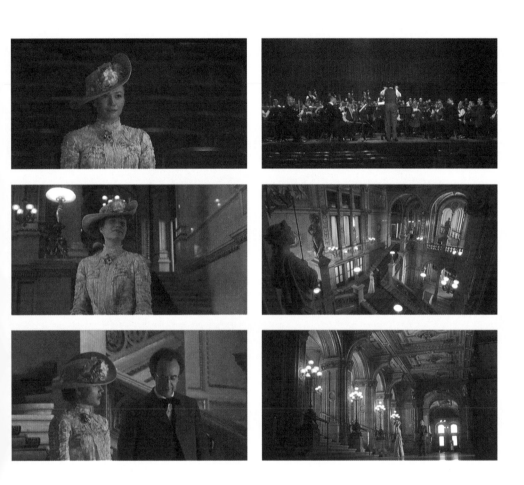

GEBIRTIG/GEBÜRTIG (2002)

LOCATION *Florianigasse 43, 8th District*

DEDICATED TO AXEL CORTI, who in his landmark film, *Welcome in Vienna* (1986), thematized the clash between former perpetrators and victims, *Gebirtig* amplifies this topic in the Josefstadt homecoming experience of exiled composer Hermann Gebirtig, who now resides in New York. He has only reluctantly come to Vienna to testify in a Nazi trial. Until the visit to his childhood home, he is framed as a celebrity enchanted by the new Vienna and his paramour Susanne. But Gebirtig's native Josefstadt epitomizes the lower-middle-class milieu that makes him lose his composure. The residents' secretive behaviour calls to mind the Nazi era: an old woman lurking behind a curtain on the *Beletage* of Florianigasse 43 closes the window to avoid Gebirtig's gaze. In the gateway a man in a blue smock loiters suspiciously with his vehemently barking dog. Two louts on skateboards emerge from the run-down courtyard and nearly run him over. 'Young people have no respect anymore!' This comment by the dog owner suggests some golden past that eludes Gebirtig. A girl in the Trafik (a Vienna tobacco shop) next door reminds Gebirtig of someone he once knew. Then a toothless hag enters and introduces herself as his childhood acquaintance. The dog-owner also turns out to be Horsti, another figure from his past. The ensuing and superficially joyous reunion is tense. The Austrians recall war-time suffering and bombing raids, barely concealing their envy of the exile whose concentration camp ordeal they have forgotten. Conceding that he made the wrong choice when joining the Nazi Party, Horsti seems bothered by Gebirtig's role in the Nazi trial. Finally alone, Gebirtig, with the hint of a Jewish prayer, places a pebble on a ledge of the old house in memory of his family. **•→Dagmar C. G. Lorenz**

Directed by Robert Schindel and Lukas Stepanik
Scene description: New Yorker Hermann Gebirtig
visits his family's former home
Timecode for scene: 1:29:58 – 1:35:05

ANTARES (2004)

LOCATION *Jedlersdorfer Strasse 99, 21st District*

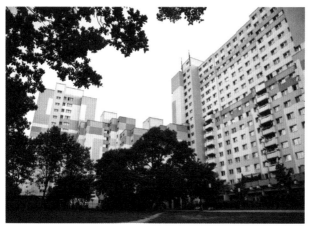

THIS IS NOT SISSI'S VIENNA. There's no Hofburg, no Prater, no golden Johann Strauss statue in the City Park. Antares takes place in and around a giant, anonymous apartment complex located somewhere on the outskirts of Vienna. We never learn where – it doesn't matter. It could just as easily be the Warsaw of Kieslowski's multi-part *Decalogue* (1989) or the Mexico City of Iñárritu's *Amores Perros* (2000) – two films with which *Antares* shares central conceits. The lives of three couples who live in the complex are intricately intertwined, but they don't know it. Nor do they know one another – except for those who are sleeping together. Behind the monotonous and indistinguishable facades, elevators and hallways of this complex lie individual stories and struggles that are just as monotonous and indistinguishable. One marriage is collapsing under the weight of a torrid affair. Another has already collapsed due to abuse. The third couple is younger, but they are already threatened by lies. Three intertwined stories of (in the words of the director) 'sex, jealousy, violence, crisis and death' that are just as bleak as the building complex in which they unfold. Vienna has been dubbed 'the world capital of feel-bad cinema', based on the recent Austrian New Wave and films like *Antares*. A capital city needs a capital building. And for new Austrian film that would be this anonymous housing complex. This is a long way from Sissi (the film), but perhaps not such a long way from the troubled marriage in which *Sissi* (the woman) found herself. **⊷ Todd Herzog**

Directed by Götz Spielmann
Scene description: *A man, a woman and their daughter*
live in an apartment in Vienna apartment complex
Timecode for scene: 0:14:03 – 0:19:10

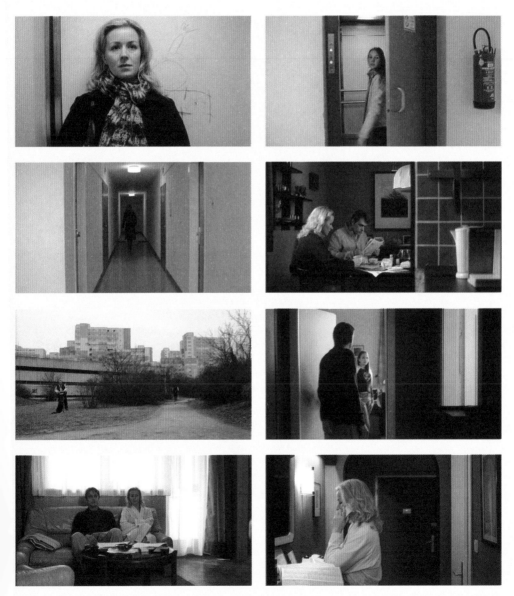

KLIMT (2006)

Café Central, Palais Ferstel, Herrengasse 14, 1st District

IN A CITY KNOWN for its coffeehouse tradition, the Café Central holds extraordinary historical status. Opened in 1876 in the Palais Ferstel, a bank building with Vienna's first shopping arcade in the monarchy's government district, it quickly became the meeting place for politicians, artists and intellectuals. Frederic Morton, who has chronicled pre-World War I Viennese social history, claims that in January 1913 alone, Freud, Tito, Hitler, Lenin and Trotsky crossed paths at the establishment. It is this status that compelled director Ruiz to shoot key scenes of his surrealist melange on Viennese Secessionist artist Gustav Klimt's life in an actual café when most of the film was created on sets. Recalling the inspiration for his unique art in fevered dreams from his deathbed in 1918, Klimt (John Malkovich) recalls encounters in the Central: sharing a drawing with his protégé Egon Schiele (Nikolai Kinski) who is frightened away by the sudden darkness that comes with news from the war front and that beckons him to the ugliness of reality. Klimt is told that he must stand 'outside of history'; he reads Dante; is led to another woman and yet another erotic-artistic adventure. Strains of Strauss waltzes and Mahler. Patrons come to blows about their opinions beyond the counter of cream cakes shaped in the likenesses of iconic Viennese buildings. Vienna as confection and illusion. The polyglot environment of the imperial city, the cafe culture, the birth of artistic and scientific modernism, and the death of the Old Order become a heady and inimitable equation. ◆**Robert Dassanowsky**

Directed by Raoul Ruiz
**Scene description: Gustav Klimt's
Vienna as coffeehouse to the world**
Timecode for scene: 1:02:47 – 1:08:08

IMPORT/EXPORT (2007)

Former Südbahnhof (Southern Train Station),
Wiedner Gürtel 1, 4th District

VIENNA'S SOUTHERN TRAIN STATION, the former gateway to the Austro-Hungarian monarchy's southern provinces, was renovated in 1953 to be the principle southern and eastern European corridor. For the countless migrants and guest workers from those regions, this station was likely their first entry point into the west and an unknown future. With an unflinching portrayal of economic exploitation and alienation in a far from unified post-1989 Europe, *Import/Export* draws on the transformative potential of this threshold space. For the Ukranian Olga, who has left her infant daughter behind to seek work in Vienna, the migrant's uncertainty and apprehension are clearly palpable, as she hesitantly exits the platform. Venturing slowly into the eerily silent and empty entry hall, Olga desperately looks for the friend who was to meet her there. This moment of uncertain arrival and tenuous reception foreshadows Olga's struggles for work and stability dramatized in the film. For the Austrian Pauli, the station marks not an entry, but another dead end. As the unemployed Pauli leaves the station for the subway platform, he is confronted by a thug whom he owes money. Pauli's debts and personal failures eventually leave him no option but to accompany his sleazy stepfather on a trip installing vending and slot machines in Slovakia and the Ukraine. This sequence preserves a space that no longer exists: in 2010 construction began on an ultramodern train hub complex to replace the dingy, oft-maligned southern station. **Nikhil Sathe**

Directed by Ulrich Seidl
Scene description: Comings and goings of hopeful
Eastern Europeans at a gateway train station
Timecode for scene: 0:40:00 – 0:43:28

THE ROBBER/DER RÄUBER (2010)

LOCATION *Heldenplatz, Hofburg Palace, 1st District*

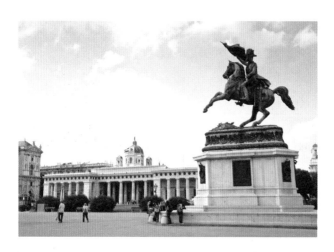

HELDENPLATZ (HEROES' SQUARE), the large plaza fronting the curved Neue Burg, the final expansion of the Hofburg palace complex (1881–1913), with its statues of Prince Eugene of Savoy and Archduke Charles on horseback, is perhaps Vienna's most iconic space, and its most conflicted. Built to glorify the monarchy's military might, it is best known today as the site where Hitler announced the annexation of Austria in 1938 to exuberant crowds. In a scene from *The Robber* filmed during the 2008 Vienna Marathon, Johann Rettenberger (Andreas Lust) crosses the finish line at Heldenplatz to set a new national record. Rettenberger (who is based on the notorious 1980s criminal Johann Kastenberger) is always on the run – literally. When he's not running marathons, he's robbing banks. We never learn what motivates him. It's not the money, which he stashes in bags under his bed. It's not the thrill; he takes no noticeable pleasure in his exploits. He just needs to run. Alone. In the opening scene, he runs laps around a prison courtyard. After that he races along Vienna's streets, sometimes outrunning competitors, sometimes outrunning the police. This is a thoroughly Viennese film, utilizing dozens of locations around the city and rarely lingering in one for more than a few seconds. At only a few moments in the film does Rettenberger stop to linger. At Heldenplatz the camera frames him in close-up smiling broadly – the only time he does so. At the end of the film he sits in a car on the side of the Autobahn somewhere in Lower Austria. What is he thinking? What does he want? We never learn. Rettenberger is conflicted and inscrutable – just like the Heldenplatz. **➼Todd Herzog**

Directed by Benjamin Heisenberg

**Scene description: Bank robber Johann Rettenberger
sets new national record in the Vienna Marathon**
Timecode for scene: 0:14:45 – 0:15:39

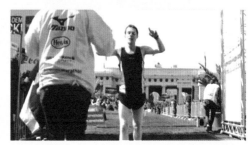

A DANGEROUS METHOD (2011)

Café Sperl, Gumpendorfer Strasse 11, 6th District

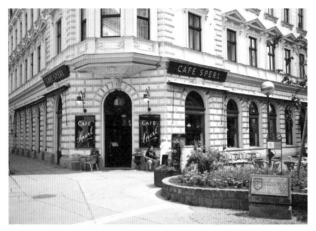

BASED ON TRUE EVENTS (1906–13), the film tells the story of the woman that came between the two leading psychiatric minds of their day and emerged as one of the first female therapists. In talks with Carl Jung (Michael Fassbender), Sabina Spielrein (Keira Knightly), a well-educated Russian diagnosed with hysteria reveals a disturbing sexual element to her dysfunction, which supports Sigmund Freud's theories regarding sexuality and emotional disorders. Through correspondence on Sabina's case, Jung and Freud (Viggo Mortensen) become friends and their first marathon meeting in Vienna – at Freud's home at the Berggasse 19 (shot on the actual staircase but not in the apartment, which is now a museum) and the Café Sperl – sharpens the relationship. Jung desires a father figure; the older Freud sees Jung as an heir to his methodology and also becomes fascinated with Sabina. When Freud learns that Jung has physically crossed the boundaries of the doctor–patient relationship with her, their clashing ideologies emerge in full force. Freud distances himself and Jung, beset with guilt regarding his adulterous relationship and the loss of his friendship with Freud, reluctantly accepts Sabina's own path and desires. The trio foreshadows the patterns of destruction and rebirth in the violent century to come. Cronenberg recalls: 'It's fantastic to feel the real history of Vienna. I was very excited when we discovered Café Sperl on our location recce because we were looking for a place for Jung and Freud to go and have a Viennese coffee and *Sachertorte*, and this is one of the most original Viennese cafes left in the city. It's incredible. We almost had to change nothing to make it feel like 1907.'
►Robert Dassanowsky

Directed by David Cronenberg
Scene description: Jung and Freud: a meeting of the
minds about the question of desire over coffee and cake
Timecode for scene: 0:25:35 – 0:27:10

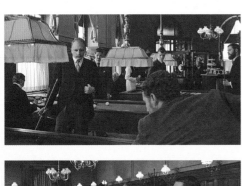
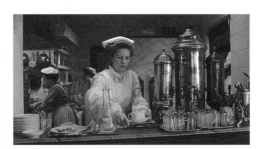

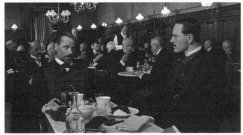
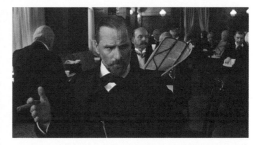

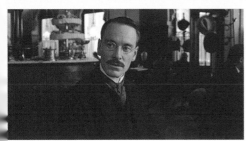
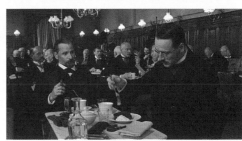

GO FURTHER

Recommended reading and useful web resources

BOOKS

Projected Cities:
Cinema and Urban Space
Stephen Barber
(London: Reaktion, 2002)
[see chapter 2, 'Urban Space in European
Cinema', pp. 61–106]

Vienna: A Cultural History
Nicholas T. Parsons
(Oxford: Oxford University Press, 2009)

Vienna: Art and Architecture
Rolf Toman
(Potsdam: Tandem, 2008)

Austrian Cinema: A History
Robert Dassanowsky
(Jefferson, NC and London: McFarland,
2005)

New Austrian Film
Robert Dassanowsky and Oliver C. Speck (eds.)
(New York and Oxford: Berghahn, 2011)

Wien im Film: Stadtbilder aus 100 Jahren
Christian Dewald, Michael Loebenstein and
Werner Michael Schwarz (eds)
(Vienna: Wien Museum/Czernin Verlag, 2010)

Inter-war Vienna:
Culture Between Tradition and Modernity
Deborah Holmes and Lisa Silverman (eds)
(Rochester, NY: Camden House, 2009)

The City as Work of Art:
London, Paris, Vienna
Donald J. Olsen
(New Haven: Yale University Press, 1986)

Architecture Vienna: 700 Buildings
(trans. Andrea Lyman)
August Sarnitz
(Heidelberg: Springer, 2008)

BOOKS (CONTINUED)

Drehort Wien:
Wo berühmte Filme entstanden
Roland Weixlgartner and Achim Zeilmann
(Berlin: be.bra, 2011)

Prater, Kino, Welt:
Der Wiener Prater im Film
Christian Dewald and Werner Michael
Schwarz (eds)
(Vienna: Filmarchiv Austria, 2005)

Willi Forst: Ein Filmkritisches Porträt
Francesco Bono
(Munich: Text + Kritik, 2010)

The Worldwide Guide to Movie Locations
Tony Reeves
(Chicago: Chicago Review Press, 2001)

ONLINE

History of Vienna –
The Making of a Capital
http://www.wien.gv.at/english/history/overview/
The official city of Vienna site featuring
a wide selection of current event, media,
cultural, historical, environmental, and
political topics.

CONTRIBUTORS

Editor and contributing writer biographies

EDITOR

ROBERT DASSANOWSKY is Professor of German and Film Studies at the University of Colorado, Colorado Springs. He is co-founder of the International Alexander Lernet-Holenia Society and contributing editor of The Gale Encyclopedia of Multicultural America. His most recent books include *Austrian Cinema: A History* (McFarland, 2005), *New Austrian Film* (Berghahn, 2011; co-edited with Oliver C. Speck), *The Nameable and the Unnameable: Hugo von Hofmannsthal's 'Der Schwierige' Revisited* (Iudicium, 2011; co-edited with Martin Liebscher and Christophe Fricker) and *Quentin Tarantino's 'Inglourious Basterds': A Manipulation of Metafilm* (Continuum, 2012; editor). His book *Screening Transcendence: Film under Austrofascism 1933–1938* (Indiana University Press) is in progress. Dassanowsky is president of the Austrian Studies Association and also active as an independent film producer.

CONTRIBUTORS

THOMAS BALLHAUSEN is Key Researcher/LNO at the Filmarchiv Austria (Austrian Film Archive) and teaches Comparative Literature at the University of Vienna. His research centres on intermediality, film history and media theory. He has worked on several international projects concerning film heritage, scientific collaboration and archive studies. Ballhausen, who is also editor for a number of journals, has also published several scientific and literary books, among them *Kontext und Prozess* (Löcker, 2005), *Delirium und Ekstase* (Milena, 2008), *Bewegungen des Schreckens* (Lang, 2010), *Bewegungsmelder* (Haymon, 2010), *Urban Hacking* (Transcript, 2010; co-editor) and *Mind and Matter* (Transcript, 2011; co-editor).

MICHAEL BURRI teaches film and European studies in the Writing Program at the University of Pennsylvania. He studied film with Andries Deinum, co-founder of *Film Quarterly*, and holds a Ph.D. in Comparative Literature from the University of Pennsylvania. Burri has written articles on Viennese topics for *German Studies Review*, *Austrian History Yearbook* and *New German Critique*, and publishes journalism in leading Czech and US dailies.

LAURA DETRE is Adjunct Instructor of History at Randolph-Macon College in Ashland, VA. Her area of research interest includes the history of emigration from central Europe, ethnic identification in the Austro-Hungarian Empire, and the diplomatic relationship between Austria and the British Empire.

SEVERIN DOSTAL, born 1982 in Vienna, was awarded the IAA's Diploma in Marketing Communications in 2003. Since then he has been an independent photographer and producer of various art projects. He has studied and worked in both France and Austria, and received his master's degree in theatre, film and media studies from the University of Vienna in 2011. He considers himself "a typical film, photo and football-aficionado" and is currently living and working in Vienna.

TODD HERZOG is Associate Professor of German Studies at the University of Cincinnati. He is co-editor of the *Journal of Austrian Studies*. His books include *Crime Stories* (Berghahn, 2009), *Rebirth of a Culture* (Berghahn, 2008; with Hillary Hope Herzog and Benjamin Lapp) and *A New Germany in a New Europe* (Routledge, 2001; with Sander Gilman). Recent articles include studies of Quentin Tarantino's *Inglourious Basterds* and Michael Haneke's *Caché*. He has also contributed to the *World Film Locations* volume on Berlin. He is currently working on ➜

CONTRIBUTORS

a book about art and surveillance and is co-editing a critical filmography of German cinema and a history of German detective fiction.

SUSAN INGRAM is Associate Professor in the Department of Humanities at York University in Toronto, Canada, where she is affiliated with the Canadian Centre for German and European Studies and the Research Group on Translation and Transcultural Contact. Before moving to York, she was a lecturer in the Department of Comparative Literature at the University of Hong Kong, and she has also taught in Germany, Poland and New Zealand. Publications such as *Berliner Chic: A Locational History of Berlin Fashion* (co-authored with Katrina Sark) (Intellect, 2010), *Zarathustra's Sisters: Women's Autobiography and the Shaping of Cultural History* (University of Toronto Press, 2003), and a series of co-edited volumes on the mutually constitutive cross-cultural constructions of central Europe and North America reflect her interest in the institutions of European cultural modernity.

DAGMAR C. G. LORENZ is Professor of Germanic Studies at the University of Illinois at Chicago. Her research focuses on nineteenth and twentieth-century German and Austrian literature with a special emphasis on contemporary Viennese society and culture, German-Jewish writing, and Holocaust literature and film. She served as Editor of *The German Quarterly*, 1997–2003. Her book publications include *Keepers of the Motherland: German Texts by Jewish Women Writers* (University of Nebraska Press, 1997) and *Verfolgung bis zum Massenmord. Diskurse zum Holocaust in deutscher Sprache* (Lang, 1992). She has edited or co-edited: *From Fin-de-Siecle to Theresienstadt: The Works and Life of the Writer Elsa Porges-Bernstein* (Lang, 2007), *A Companion to the Works of Elias Canetti* (Camden House, 2004), *A Companion to the Works of Arthur Schnitzler* (Camden House, 2003), *Contemporary Jewish Writing in Austria* (University of Nebraska Press, 1999), *Transforming the Center, Eroding the Margins* (Camden House, 1998) and *Insiders and Outsiders: Jewish and Gentile Culture in Germany and Austria* (Wayne State University Press, 1994).

JOSEPH W. MOSER is Visiting Assistant Professor of German at Randolph-Macon College. Since 2006 he has been Book Review Editor for *Modern Austrian Literature* – now named *Journal of Austrian Studies*. His dissertation on 'Thomas Bernhard's Dialogue with the Public Sphere', was defended at the University of Pennsylvania in 2004. His recent publications have focused on Thomas Bernhard, Lilian Faschinger, Franz Antel's *Bockerer* films, and the city of Czernowitz. His interests include contemporary German and Austrian Jewish literature and culture, German language Holocaust literature, as well as German and Austrian Film and Television, and he is currently working on a book on German-language actors Hans Moser, Paul Hörbiger and Theo Lingen.

MARKUS REISENLEITNER (Ph.D., University of Vienna) is Director of the Graduate Program in Humanities and the coordinator of the European Studies program. He is also affiliated with the Graduate Program in Communication and Culture, and the Canadian Centre for German and European Studies. Before joining York's Division of Humanities in 2006, he taught at the University of Vienna, the Vienna campus of the University of Oregon's International Program, the University of Alberta, and Lingnan University in Hong Kong, where he was Head of the Department of Cultural Studies from 2004–06. He is a research associate of Hong Kong's Kwan Fong Cultural Research

and Development Programme, a member of the executive committee of the Canadian Comparative Literature Association, and a member of the editorial collective of the web journal *spacesofidentity.net*.

ARNO RUSSEGGER, born in 1959, completed his studies in German Philology and Anglo-American Philology with a thesis on Robert Musil's theory of images, 'Ki–ne–ma mundi'. At present he is Associate Professor with the Institute of Germanic Studies at the Alpen-Adria-University of Klagenfurt. His teaching and research activities focus mainly on Austrian literature (since 1900), the relationship between film and literature, film analysis, literature for children and adolescents, and the literary business community.

NIKHIL SATHE is Assistant Professor of German and Language Program Coordinator at Ohio University. His research interests are focused on Austrian Studies, language pedagogy, and literature and culture from the twentieth century to the present. His forthcoming publications include articles on Norbert Gstrein's text *Einer*, films by Ruth Mader and Barabara Gräftner, *Uwe Timm's memoir Am Beispiel meines Bruders*, as well as a number of pedagogically oriented articles. He is a contributor to *New Austrian Film* (Berghahn, 2011).

HEIDI SCHLIPPHACKE is Associate Professor of German at Old Dominion University. She has published widely on issues of gender and kinship in the German Enlightenment and in post-war German and Austrian literature and film. She recently published an essay on the popular *Sissi* films in *Screen*, and is currently working on a co-edited volume on the global reception of the cult of 'Sissi'. She is a member of the executive committee of the Austrian Studies Association

and on the editorial board of the Journal of Austrian Studies. Her monograph, *Nostalgia After Nazism: History, Home and Affect in German and Austrian Literature and Film* (Bucknell University Press) appeared in 2010.

OLIVER C. SPECK is Associate Professor of Film Studies at Virginia Commonwealth University's School of World Studies. His areas of expertise are French and German cinema. Dr Speck's book, *Funny Frames: The Filmic Concepts of Michael Haneke* (Continuum, 2010), explores how a political thinking manifests itself in the oeuvre of the Austrian director. He is also co-editor (with Robert Dassanowsky) of *New Austrian Film* (Berghahn, 2011) and contributor to *Quentin Tarantino's 'Inglourious Basterds': A Manipulation of Metacinema* (Continuum, 2012).

JUSTIN VICARI is a widely published poet, critic, fiction writer and translator. He is the author of *Male Bisexuality in Current Cinema: Images of Growth, Rebellion and Survival* (McFarland, 2011) and *Mad Muses and the Early Surrealists* (McFarland, 2011), as well as a forthcoming book on the films of Gus Van Sant. He has translated François Emmanuel's *Invitation to a Voyage* (Dalkey Archive Press, 2012) and has also contributed to the anthologies *New Austrian Film* (Berghahn, 2011) and *Inglourious Basterds: A Manipulation of Metacinema* (Continuum, 2012).

MARY WAUCHOPE received her Ph.D. from the University of California, Berkeley, and is currently Director of German Studies in the Department of European Studies at San Diego State University. She has published a book and several articles on topics of Germanic linguistics and European cinema, in particular post-war German and Austrian film. She is also a contributor to *New Austrian Film* (Berghahn, 2011).

FILMOGRAPHY

All films mentioned or featured in this book

'38 – Vienna Before the Fall/
'38 – Auch das war Wien (1986) — 49, 71, 86
Adventure in Vienna/Abenteuer in Wien (1952) — 7, 31, 43
Amadeus (1984) — 5
Angel with the Trumpet, The/
Der Engel mit der Posaune (1948) — 68
Antares (2004) — 7, 109, 114
April I, 2000/I. April 2000 (1952) — 31, 44, 69
Archduke and the Country Girl, The/
Erzherzog Johanns grosse Liebe (1950) — 68
Bad Timing: A Sensual Obsession (1980) — 71, 78
Before Sunrise (1995) — 89, 91, 98
Before Sunset (1994) — 5
Best Day of My Life, The/
Heut' ist der schönste Tag in meinem Leben (1936) — 11, 22
Bitter Sweet (1933) — 9
Black Brown White (2011) — 106
Bock for President (2010) — 107
Bockerer/Der Bockerer (1981) — 71, 80
Born in Absurdistan/Geborden in Absurdistan (1999) 91, 102,107
Boys from Brazil, The (1978) — 71, 74
Breath of Scandal, A (1960) — 5
Bride of the Wind (2001) — 109, 110
Cafe Electric/Café Elektric (1924) — 5, 6
Cardinal, The (1963) — 51, 56
City Without Jews, The/Die Stadt Ohne Juden (1924)11, 14, 48
Counsellor Geiger/Der Hofrat Geiger (1947) — 68
Court Theater aka Burg Theater/Burgtheater (1936) — 31, 32
Crash Test Dummies (2005) — 107
Crazy World of Ute Bock, The/
Die verrückte Welt der Ute Bock (2010) — 107
Dangerous Method, A (2011) — 5, 109, 122
Daybreak (1931) — 8
Dishonered (1931) — 5, 8
Dog Days/Hundstage (2001) — 7
Doll of Happiness, The/Die Glückspuppe (1911) — 28
Dream of an Austrian Reserve Officer, The/
Der Traum eines österreichischen Reservisten (1915) — 29
Emperor Waltz, The (1948) — 5, 9
Empress Maria Theresa/Maria Theresia (1951) — 68
Episode (1935) — 9
Eroica (1949) — 68
Escapade (1934) — 9
Eternal Waltz/Hoheit tanzt Walzer (1935) — 9
Eva (1935) — 9
Eva, The Sin/Eva, die Sünde (1920) — 29
Excluded, The/Die Ausgesperrten (1982) — 71, 82
Exit... But Don't Panic/ Exit... nur keine Panik (1980) — 89
Eyes Wide Shut (1999) — 8
Firefox (1982) — 5
Flirtation/Liebelei (1933) — 9
Four in a Jeep/Die Vier im Jeep (1951) — 7, 31, 40, 69
Franz Schubert (1953) — 68
From Mayerling to Sarajevo/ De Mayerling à Sarajevo (1940) — 9
Frühlingsparade (1934) — 9
Gaslight (1944) — 9

Gebirtig/Gebürtig (2002) — 49, 109, 112
Gently My Songs Entreat/Leise flehen meine Lieder (1933) 7, 9
Golden Viennese Heart, The/Das goldene Wiener Herz (1911) — 28
Good News (1990) — 107
Good Night Vienna (1932) — 9
Great Waltz, The (1938) — 9
Gurbet – In der Fremde/Away From Home (2007) — 107
Hallo Taxi (1958) — 68
Heart of the Proletarian, The/Das Proletarierherz (1913) — 29
Hello Porter/Hallo Dienstmann (1952) — 68
I Love Vienna (1991) — 91, 94, 107
Illusionist, The (2006) — 5
Immortal Beloved (1994) — 91, 96
Import/Export (2007) — 107, 109, 118
Jesus of Ottakring/Jesus von Ottakring (1976) — 7, 51, 66
Johann Strauss on the Beautiful Blue Danube/
Johann Strauss an der schönen blauen Donau (1913) — 29
Journey, The (1959) — 5
Joyless Street, The/Die freudlose Gasse (1925) — 48
Juarez (1939) — 9
Julia (1977) — 5
Klimt (2006) — 109, 116
Last stop/Endstation (1935) — 9, 11, 20
Letter from an Unknown Woman (1948) — 9, 88
Life and Loves of Mozart, The/Mozart (1955) — 68
Little Night Music, A (1977) — 5
Living Daylights, The (1987) — 7, 89, 91, 92
Long Way, The/Der weite Weg (1946) — 68
Mad Butcher, The/Lo Strangolatore di Vienna (1971) — 7
Marika/Kind der Donau (1950) — 69
Masquerade/Maskerade (1934) — 7, 9
Mayerling (1936) — 9
Mayerling (1968) — 5, 51, 60
Merry-Go-Round (1923) — 6, 89
Miller and his Child, The/Der Müller und sein Kind (1910) — 28
Miracle of the White Stallions (1963) — 51, 58
Mizzi of the Prater/Die Pratermizzi (1926) — 88
My Russia/Mein Russland (2002) — 107
Niagara (1953) — 9
Night is Young, The (1935) — 8
Night Journey/Nachtreise (1994) — 107
Night Porter, The/Il Portiere di Notte (1974) — 51, 64
Ninotchka (1939) — 9
Northern Skirts/Nordrand (1999) — 91, 100, 106
Operation Spring (2005) — 106
Operetta/Operette (1940) — 9, 31, 34
Orphan Boy of Vienna/Sigende Jugend (1936) — 11, 24
Paper Bridge, The/Die Papierene Brücke (1987) — 49
Pebbles/Kieselsteine (1983) — 49, 71, 84
Piano Teacher, The/La Pianiste (2001) — 91, 104
Plasma (2004) — 89
Prater (1936) — 7, 11, 26, 89
Prater (2007) — 89
Queen of Sin and the Spectacle of Sodom and Gomorrah/
Sodom und Gomorrha (1922) — 11, 12
Ray of Sunshine/Sonnenstrahl (1933) — 6, 7, 11, 16